on the road with your digital camera

on the road with your digital camera

Michael Freeman

ILEX

First published in the UK in 2004 by

I L E X

The Old Candlemakers
West Street
Lewes
East Sussex BN7 2NZ

ILEX is an imprint of The Ilex Press Ltd
Visit us on the Web at:
www.ilex-press.com

This book was conceived by
ILEX, Cambridge, England

Publisher Alastair Campbell
Executive Publisher Sophie Collins
Creative Director Peter Bridgewater
Editor Adam Juniper
Design Manager Tony Seddon
Designer Hugh Schermuly
Artwork Administrator Joanna Clinch

Commissioning Editor Alan Buckingham
Development Art Director Graham Davis
Technical Art Editor Nicholas Rowland

British Library Cataloguing-in-Publication
Data: a catalogue record for this book is
available from the British Library

ISBN 1-904705-51-0

Printed and bound in China

For more information on this title:
www.trapuk.web-linked.com

Contents

Introduction

This is what I do for a living. I travel and photograph, for a little more than half of each year. Indeed, my wife calls me a 'professional tourist'. Actually, I travel to photograph, which is a little different, because each trip has one or more assignments, and there is a distinct, different purpose each time. And for once, I am writing a book partly for my own benefit, a manual that collates the kind of information that I, as a photographer who travels, need.

The broad idea of travel has a long and intimate relationship with the camera. By the middle of the nineteenth century photography had become practicable, although by today's standards immensely laborious. The weight of equipment, and the difficulty and uncertainty of preparing and processing plates on location did not deter scores of photographers from setting out to explore the world. They had a practical motive for this, because the invention of the new medium coincided with an insatiable demand in the West to know how the world looked – its monuments, landscapes, cultures. Travel photography aimed to satisfy that demand – and has never stopped. The major difference now is that millions of people do it.

Digital photography brings a new element to this. Some may feel a little nervous about taking a digital camera and its paraphernalia on the road. What if it goes wrong? What if the connections are not compatible? Can I find what I need in Bangkok? Or Tulsa? The answers are surprisingly simple, and come down to preparation. The trick is to know what you can plan for and what is best tackled once the trip has started, as you go along. This applies as much to the subjects you are going to photograph as well as to the equipment you will use. Technically it may be a little more complex than shooting with film, but only because the possibilities are greater for capturing images in all kinds of situations, and for guaranteeing that their qualities of colour, contrast, and clarity are as you wanted them to be. If travel broadens the mind, digital cameras broaden travel photography.

Light and dark
One view of the famous slot canyons of Arizona. The play of dark and light makes for a beautiful display of contrast which you should always look out for with your travel photography.

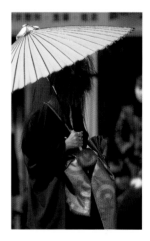

Japanese gothic
A unique shot of something characterful and spontaneous is always a good idea. This is a shot of a gothic geisha-styled girl in Japan.

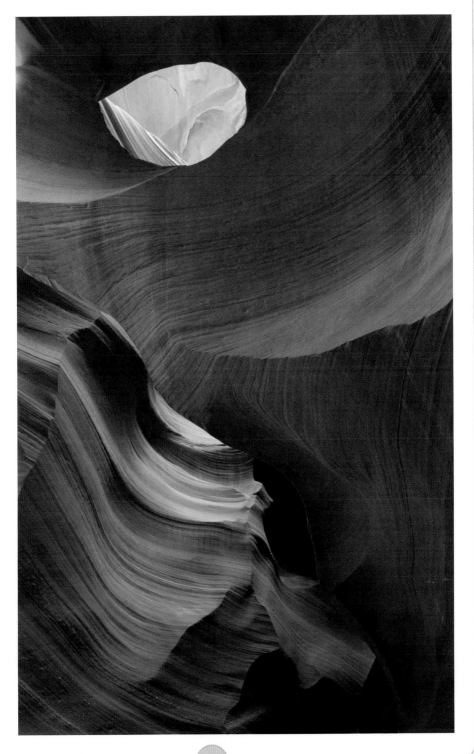

PLANNING AND PREPARATION

I make no apologies for spending half of this book on preparation – the work that needs to be done before you get in the car or step onto the aircraft. The idea here is to make life smooth and easy on the road, so that the adventures are reserved for the place, the people, and your experiences, not the dramas of figuring out how to continue shooting when a vital piece of equipment has been left behind, or the fun in rewiring a hotel room because the electrical outlets bear no resemblance to anything you've ever seen.

There are many ways of travelling, even professionally, and I certainly don't want to suggest through this book that there is only one, buttoned-down way of taking your digital cameras. Some travellers have always liked to fix a schedule down to the precise minute, never deviating from their perfect plan. At the opposite extreme are those who steadfastly refuse to commit themselves to anything, determined to follow the whim of the moment. And in between are infinite shades of travelling style. Personally, I like to lock down certain arrangements (a couple of flight dates, for example, a hotel reservation here and there, the bookings for a key event), and leave the gaps between open to last-minute decision changes. Of course, one of the advantages of planning is that you can know in advance exactly which arrangements you absolutely do have to make right now, and which don't matter. If you travel in high season anywhere, you have less flexibility than if you are going somewhere unpopular or out of season.

I also believe that you can't know too much about what you are setting off to photograph, whether a place, people, or event. For a professional photographer shooting for a client who is expecting top results, it would be irresponsible not to learn everything possible related to the assignment. This doesn't mean that you have to burden yourself with a reference library, but at least cover all the information sources and have the cameras and every other piece of kit sorted out.

At the end of the day, we are photographers working with precision equipment that needs to be cared for and kept in good order. One luxury that we cannot indulge ourselves in is to be so relaxed and laid back that we just

hope the cameras can look after themselves. So much digital equipment is very specific and cannot be interchanged with that from other manufacturers that it is highly risky relying on being able to acquire the right bits and pieces on the road. One basic assumption you should make is that you must have everything that you will need for the camera with you before you leave, including film, memory cards, and additional lenses, plus any essential accessories, such as filters. Remember to also include any item of equipment that you personally cannot do without.

Lake Palace
A view of the Lake Palace hotel, which occupies its own island in the middle of Lake Pichola, Udaipur, in Rajasthan.

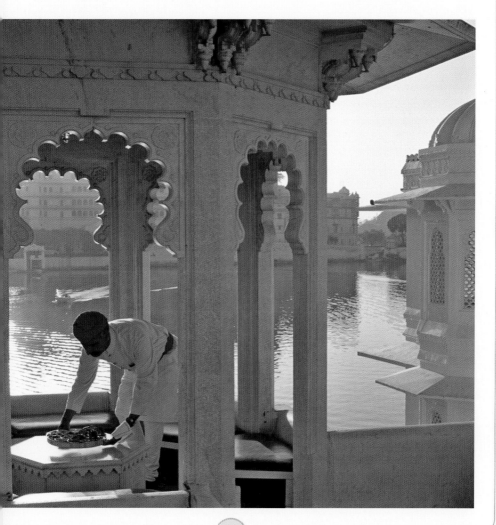

Location, location

MANY YEARS AGO, while I was being briefed for a book assignment at Time-Life, the Art Director, Lou Klein, gave me a piece of advice in his usual didactic way. 'Photography', he said, 'is about being in the right place at the right time.' Yes, it sounds obvious, but what good advice, because it lays out the priorities. He didn't mention composition, lighting, sense of timing, or any of that, simply because these skills were taken for granted. Of course you had to know how to make a good picture, but the most important thing was to put yourself in position to shoot. Photographers who travel professionally put a major effort into logistics, and the first priority is the location. This means finding out where it is, how to get there, and how to locate yourself in relation to it.

Maps are the key, whether topographical, street, plans, or aerial photographs, all of which are available in surprising abundance for most destinations. Having a map makes everything quicker and avoids wasting time and getting lost. I rely heavily on them – a street map for city shooting, a topographical map for trekking and landscapes, and aerial photographs if at all possible.

Being prepared
Taking a map and compass with you on your walking trips will save you lots of confusion.

GLOBAL POSITIONING SYSTEM

Now that GPS receivers are small and accurate, they are becoming part of the standard equipment for serious travellers. A model like that shown here weighs only about 150g (5oz) and works anywhere that has a clear view of a large section of the sky. By tracking the visible satellites it will register your location, usually to within several metres, and display the coordinates as latitude and longitude or according to the more popular national grid systems, such as the Ordnance Survey grid reference in the UK. There are two main ways of using this information. One is to load a digital map into the GPS – it will then show your location in relation to the features around you. However, these maps are not cheap, and contain so much data that you will need to load just one at a time (and don't expect to have all the contour lines from a topographical map).

The easier, slightly messier alternative, is to carry a printed map and check your coordinates on that.

http://www.earth-info.org/
http://plasma.nationalgeographic.com/mapmachine/

Using maps

It is always a good idea to have a map and compass handy wherever you plan to walk. It can be a lifesaver if you are trekking somewhere you haven't been before.

FINDING SUBJECTS BY ONLINE MAPPING

I wanted to shoot certain ancient Bronze Age burial sites, and work out a route for driving from one to another. I had to enter a general request for a specific area of Wales via a search engine, find from that a website with a list of locations and their grid references, then use an online mapping service to locate it. This particular map website also offers aerial photographs to the same scale. I printed both out and used them to navigate my way.

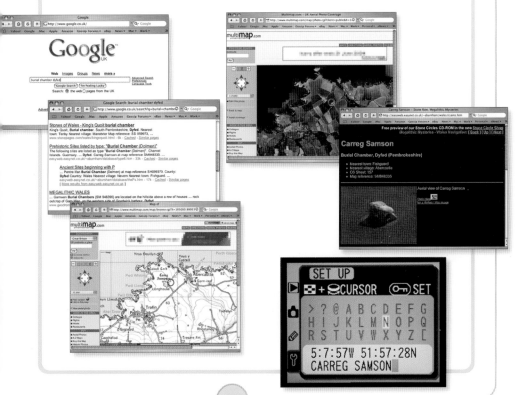

Self-assignment

ALTHOUGH IT MAY SEEM that professional photographers enjoy many advantages, there is a constant pressure to deliver good pictures. One distinct benefit, however, is that professional photography is always focused – there is an aim, which usually begins with a brief from a client. This is what keeps everything on track. Nevertheless, few successful editorial photographers simply sit around waiting for clients to come up with assignments; it's normal to initiate projects as well. Self-assignment is not just an exercise, but an important outlet for your imagination and a way of directing your effort.

Professionally, an assignment begins for a photographer with the brief from the client, and this usually spells out some specific aims. Generalized stories about countries or large areas are much less common than they once were, and even if the brief is limited to a vague statement, someone then has to extend it to specific requirements – that person is usually the photographer. The aim might be to show a certain aspect of a location, an event, a ceremony, some

Room with a view
Always keep an eye open for unusual viewpoints when you are on assignment, even if it's a self-imposed one. You never know when it will be required by a client. This was one of several shots I took at the Lake Palace hotel, occupying its own island in the middle of Lake Pichola, Udaipur, one of the most picturesque cities of Rajasthan.

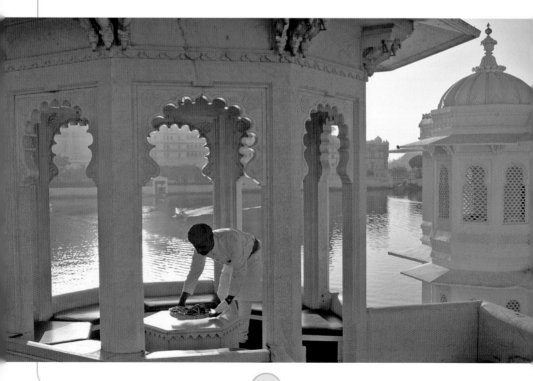

activity, a cultural feature – the possibilities are endless. Nevertheless, it is important to spell this out in advance, because this in turn has to be fleshed out into a shotlist.

A shotlist is self-defining, but usually begins with jotted notes from your research into the place you plan to visit. In practice, shotlists, or picture scripts as they are sometimes called, are dynamic rather than static. They get added to and subtracted from as the shooting proceeds, from day to day. You can follow a shotlist methodically or use it simply as an occasional reminder, depending on how you like to work. Some items on the list will be essential, others you hope for, others may be just secondary. Certain images that seem a good idea in advance may turn out to be impractical, unachievable, or simply not so strong after all. Other possibilities will suggest themselves on the spot. See The daily edit, page 126, for suggestions on how to continuously analyze the shoot as it progresses.

There is then the matter of treatment and style. Thinking about these at the start can help add depth to your shoot and bring originality to it. There are some low-level practical considerations, including the following:

- Which focal lengths of lens to concentrate on, for the character they give.
- What natural lighting conditions to look for.
- Shooting at different scales, from distant to close (views to details).
- Whether to stress the continuity of images or variety.

Fairy lights
This night-time view of the Lake Palace Hotel on Lake Pichola was shot using a tripod and a long exposure to make the most of the beautiful lighting.

On the waterfront
A different viewpoint of Lake Palace hotel from the waters of Lake Pichola.

The higher-level aspects of treatment and style are more difficult to pin down, being dependent on a photographer's ability and creativity. Nevertheless, it helps to develop and follow your own way of choosing, composing, and lighting images. Most photographers have favourite ways of shooting – one might look for people appearing small in the frame of every landscape, another might add a touch of flash to shots.

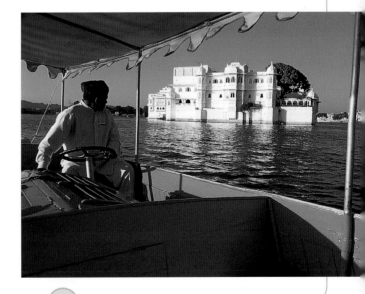

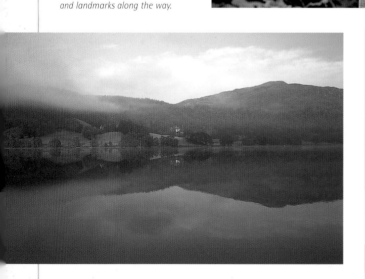

Real-life shoot

This real-life example was a story for the Smithsonian magazine on a two-week walk across England devised by the famous writer and walker Alfred Wainwright. The entire shoot was much larger than the small selection shown here. There were certain key shots and subjects needed to match the text, including the start and end points, pictures of people doing the walk, and landmarks along the way.

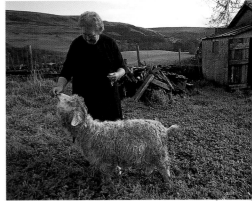

Researching locations

ONCE AGAIN, the Internet is the prime source for research, unparalleled for speed. The example shown, below, gives an idea of basic resources: an initial information-gathering for a trip to the Sudan. There are likely to be many websites for any one country, and you will need to sift through the dross, and also look for the following, some of which are illustrated here:

● The CIA (Central Intelligence Agency) World Factbook, accessed through the CIA home page. Excellent, precise summaries.

● The official website of the country's government. These vary immensely in value according to the country, which government department operates it, and who has designed it. Of course, all nations put an attractive face on any presentation, but you can expect nondemocratic countries, particularly those with serious political problems, to offer disinformation.

● The website of the country's embassy. These are concentrated in the US. The same caveat as above applies.

● A university with a substantial department for studies in that region. In this example, The University of Pennsylvania has a valuable webpage. This kind of institution offers links to other relevant sites.

● Travel advisories from the US State Department's Consular service. Similar advisories are offered by other countries, but the US is particularly developed in this area. If there are potential problems for travellers, you will find them here, regularly updated. Note, however, that such advisories tend to be cautious, perhaps more than necessary.

Guidebooks, at least of the practical kind, are an important supplement to online information, not least because they are more convenient to carry on a trip than collated print-outs from websites. The most popular series is Lonely Planet, but they face stiff competition in quality from other publications, such as Rough Guides and Footprint Guides. The value of all these guides is principally in their coverage of practicalities,

Walking maps and books
When researching locations, find yourself as much information as you can from guidebooks and walking maps.

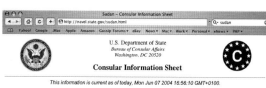

Checking out
Make use of the US State Department's Consular service for up-to-date information and advice on the country you plan to visit. Alternatively, scan the website for the individual country's embassy.

including internal travel, hotels, and restaurants. Background information on history, current affairs, and culture tends to be mixed, depending very much on the individual author. Remember that these guides are written by travel journalists, who are rarely experts. Inaccuracies are inevitable, which is why I always take at least two different guides.

All this is basic stuff for intelligent travel planning, but as photographers we also need to prepare ourselves for the picture possibilities. Guidebook descriptions mean nothing; only another photographer can really recommend photo opportunities, and even then every eye is different. You may have to look to illustrated books and back-issues of magazines like *National Geographic* and the German *GEO* for a visual briefing. The problem with using good photography as an information source is that the images are likely to be interpretative, where a more objective, even pedestrian, view would be more useful.

http://www.cia.gov/cia/publications/factbook/geos/

POSTCARDS

For a quick preview of the local sights when you are on the road, take a look at the postcard rack at the airport or hotel lobby. Even though you may not be tempted to shoot a similar view, the local photographers know what is where.

The CIA World Factbook
The CIA's World Factbook is an indispensable source of tips and hints on your chosen destination.

Light themes

BECAUSE THE QUALITY OF LIGHT brings so much to the character of a photograph, it is possible to aim deliberately for a particular kind of lighting throughout one assignment. Some professional photographers even make this a signature of their work.

For general outdoor shooting, probably the most favoured natural light for most photographers is moderately low sunlight, as at mid-morning and mid-afternoon. This is the lighting that dominates, for instance, travel brochures. Variations and extensions of this are when the sun is quite close to the horizon, although here the shooting window is much shorter, which means fewer images. The reason for the commercial popularity of bright-sun-but-not-too-high light is that this is tourist weather – the conditions in which most people like to travel for pleasure.

Some photographers, however, think that you can have too much of a good, or at least predictable, thing. Certainly, given the demands of publishing and advertising constantly to come up with striking, different new images, travel photographers are under pressure to find different light treatments. Here, the style of the publication and strength of the art director have a major effect in pushing photographers to explore lighting possibilities. The aesthetics of 'nice lighting' are, after all, quite fashionable. And fashions change.

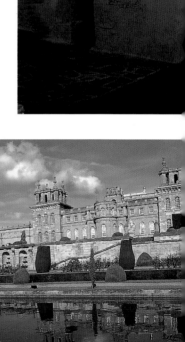

Moderately low sun

This is general-purpose attractive scene lighting with the sun at approximately 30° to 60° elevation, the most commonly used when landscapes, buildings, and overall views have to look good in a wish-you-were-here way. Typical for travel brochures and vacation magazines, and for these reasons efficient and pleasant but not necessarily

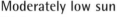

Late afternoon
With the sun below 40°, modelling is good but not dramatic – efficient and pleasant lighting for subjects with relief, such as this view of Blenheim Palace, England.

Almost sunset

When the sun is just a hand's breadth away from setting or rising, and the sky is clear, shadows are almost horizontal and the colour golden, as in this view of a famous church on the Greek island of Mykonos.

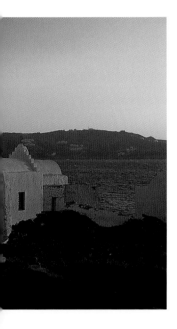

eye-catching. Overused. On the other hand, an old friend of mine, highly successful in stock photography, says, 'blue sky is money in the bank'.

Golden light

Very low sun, in the hour after sunrise and before sunset, tinged yellow to red. Almost universally thought of by viewers and readers as special and evocative, the reward for getting up early. Technically very useful because it offers different lighting according to the camera position: frontal, side, back, silhouettes. Fairly difficult to manage because of clouds (any that obscure the sun are at a considerable distance, move relatively slowly across the view, and are at a shallow angle to the camera, with small gaps between them) and because the time available to shoot is short. Unless clear skies are predictable, there is a high failure rate.

Sun on the horizon

Sunrise and sunset have a universal appeal. Many scenic sites that are well-known have their mandatory viewpoints, where most visitors go to watch the sun itself rather than the light it casts over the landscape. This is one of the great clichés, best avoided unless the situation really is commanding. This kind of shot stands a chance of being successful only if there is something else of visual interest – for instance, a silhouetted subject in front or interesting clouds. For the sun's disc to make any impact in an image, you need a long lens – at least 300mm efl.

Exactly sunrise

No different in principle from sunset, and again depending on clear air for the full red effect, the moment lasts just a few minutes and is often most effective when used for a silhouette, as with the rock formations known as The Mittens in Monument Valley.

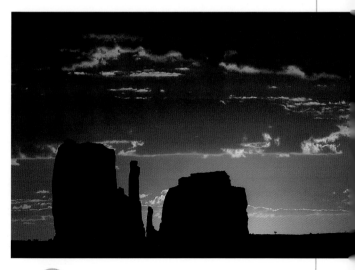

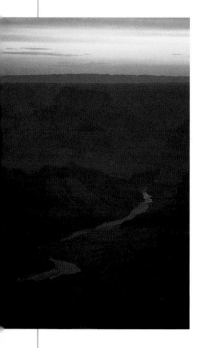

Twilight

When the sun is just below the horizon – the period between sunset and darkness, and between darkness and sunrise. The time available depends on latitude (shorter in the tropics) and on cloud cover (longer in clear weather). Interesting conditions, not least because this is an uncommon time to shoot. Although most often used for landscapes that include the sky, because clouds lit from below the horizon can be extremely attractive, it can offer very subtle effects for portraiture and details. Under a clear sky, the overall hue is likely to be blue, but with opposite warm tones from the direction of the sunset/sunrise and its reflections from buildings.

Floodlighting, available lighting

More and more buildings have floodlighting at night, and lighting design is a growing industry. The effects are often striking, but may call for a recce the evening before to assess what kind of a photograph they would make. The great advantage of this artificial lighting approach is that it is not weather-dependent. Nevertheless, clear weather can still be valuable because of twilight tones (deep blue sky, warm glow from the direction of sunset/sunrise). Indeed, timing is critical for floodlit buildings and evening cityscapes, because twilight adds some definition to shadow areas and to the outline of buildings and trees. Digital

Grand Canyon
The distances, visible upriver from the Desert View overlook, make the bluish cast mingle with the remnants of warm tones at dusk.

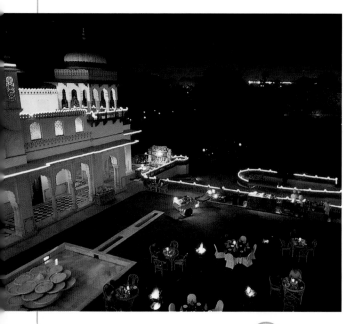

Floodlighting
The arches and cupolas of the Rambagh Palace, converted into one of India's grandest hotels, lit by a mixture of concealed lighting. Colour is not an issue when shooting digitally – it can be altered later either globally or selectively. For added definition of the diners on the lawn, the camera's pop-up flash was used at full power.

Using rear-curtain flash
The Semana Santa (Holy Week) procession in Lima, Peru. The crisp, focused finish from the rear-curtain flash makes the inevitable motion blur from handholding acceptable.

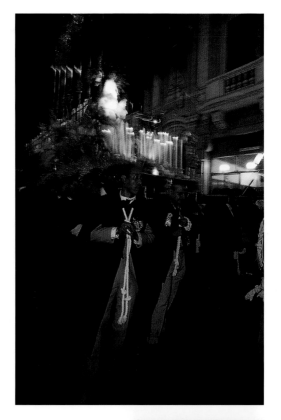

photography has a major advantage over film in dealing with the unpredictable colours of floodlights, which include the yellows of sodium vapour and the blues of mercury vapour. You can see the effect immediately on the LCD screen, and then choose the appropriate colour correction with the white balance setting.

In interiors, digital photography makes it easy to work with the lighting that is available – always a challenge with film photography. The white balance can be switched on the fly, and there is a choice between the two most common kinds of illumination – tungsten (incandescent) and fluorescent. Switching to a higher ISO sensitivity rating is also simple. The advantage of working indoors without flash is that you can shoot unobtrusively, in cafés, bars, and other places where a flash would advertise your presence and might be unwelcome.

Supplementary flash

This style of lighting has an effect only on the nearer parts of a scene, because of the limited range of on-camera battery-operated flash. However, the effective distance can be stretched by switching the sensitivity of the camera to its highest ISO setting. 'Supplementary' means adding the flash effect to the existing lighting, rather than replacing it, so that the surroundings and background register clearly. There are two distinct ways of using supplementary flash: in daylight to brighten up people and foregrounds, and at night and in interiors to add a sharp, clear image to a time exposure which has interesting blur. Both effects are strikingly artificial.

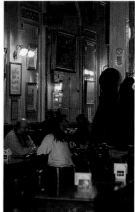

Available tungsten
A café (lit with tungsten lamps), shot with a tripod and the white balance set for incandescent. The lamps, probably 100W, register orange at this WB setting.

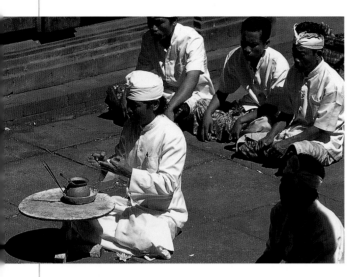

Tropical midday
The unavoidable problems of a high sun and clear air, as in this shot of a Balinese temple ceremony at Pura Besakih, are high contrast – more extreme here because of the white costumes – and shadows that pool underneath. The essential thing when shooting digitally is to avoid clipped highlights by, if necessary, underexposing.

High-contrast sunlight

Intense overhead sunlight, at its most extreme in the tropics in the middle of the day, is traditionally one of the most avoided lighting conditions in photography, because of its stark, flat effect, usually considered unflattering. As a result, it is fairly uncommon in professional photography, all the more reason for experimenting with it. One solution is to use strong shadow shapes as a key part of the composition, and this calls for some underexposure to keep sunlit colours well-saturated, as well as imaginative composition.

Soft haze

Haze conjures up feelings of summer or woodsmoke, and occurs when there is a temperature inversion that has been going on for a few days, or dust, or some kind of pollution. The lighting effect is to soften the scene, reducing contrast, making colours more pastel, and even sometimes adding a tinge of yellowish colour overall. In the short term it often can be predicted, as when there are bush fires nearby, or a high pressure system over a city known for its polluted air (like Mexico). As an overall addition to the light, haze easily lends consistency to one take of pictures.

Overcast

Another of the traditionally avoided types of natural light, usually considered dull, boring, and rather depressing. Nevertheless, as with high-contrast sunlight (above), its dislike by most photographers makes it an untrammelled

Backlit haze
Airborne dust and backlighting make this outcrop in the Grand Canyon almost disappear, and the effect is subtle and impressionistic. Strong haze, dust, and fog generally work best when there is just a hint of shape in the image.

lighting theme. Its advantages are (paradoxically) good colour saturation provided that you avoid any hint of over-exposure, a sombre mood, and a clear treatment for complicated subjects, such as vegetation. Greens do very well in this light. One essential is to avoid as much as possible including the sky in the image, as it will appear washed out if you expose correctly for the ground.

Thick cloud

An overcast day in the Yorkshire Dales, northern England. Provided that you exclude the sky from the image, colours in overcast weather are well-saturated. Tonal contrast is low, but the rich greens more than make up for it.

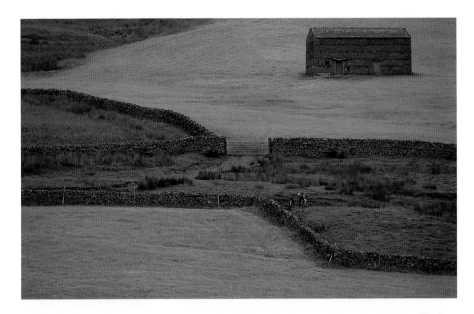

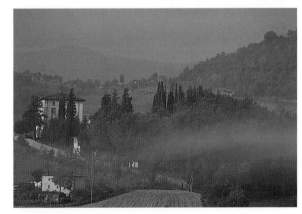

Morning mist

A Tuscan hillside near Poppi reacts to the early morning summer sun with a brief mist, and the effect on the image is to blend tones and hues into a smaller range.

Rain

Much of what I said for overcast light applies for rain, only more so. It also has its own special lighting appearance because of all the reflections from wet surfaces. Light-to-moderate rain is normally invisible to the camera as it falls, at a distance appearing like a light mist. Heavy downpours, however, can be dramatic. In addition to the lighting effect of rain, there are also its effects on people and activities. Being uncomfortable for shooting, rain is a relatively unused lighting condition.

In the rain
Unless rain is very heavy, it normally doesn't register in images, and the lighting effect is similar to overcast. Here, the mass of clouds and the layered haze gives the viewer a clue.

Stormlight

A rare break in the clouds in stormy weather, particularly when the sun is quite low, is always dramatic, and under the right circumstances (good camera position and the shaft of light striking an interesting subject) easily makes the killer shot. It combines the best of 'golden light' and a dark, theatrical sky, with strong contrast. It is also highly unpredictable and may last for only seconds. If it doesn't happen at all, you are left facing a dull, grey day. This lighting theme is almost impossible to plan for, but is valued for being exciting and unusual. Such pictures tend to be unique, hardly ever repeated. I include lightning in this theme.

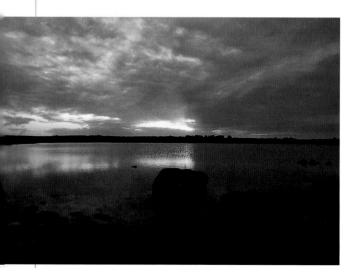

Dozmary pool
Dozmary pool in Cornwall, legendary site where King Arthur commanded Bedivere three times to cast his famous sword, Excalibur, into the waters. In ordinary light it has no special presence, but a briefly clearing storm one sunrise added the necessary drama.

TWO-SEASONS ANGKOR

Revisiting the Cambodian ruins at Angkor for a story commissioned by the *Smithsonian* magazine, I had to find a new approach. Over the years I had already built up a collection of mostly architectural images of the many monuments with the setting or rising sun hitting the right spot. This article had to be different (and the magazine would also have the choice of previously shot material). I chose to go in the rainiest month of the monsoon, early September, and work without sunlight, looking instead for saturated greens, shooting for darker images, and concentrating on people and activity. Advantages were the more exuberant foliage, the mosses and lichens coating the stones, and water.

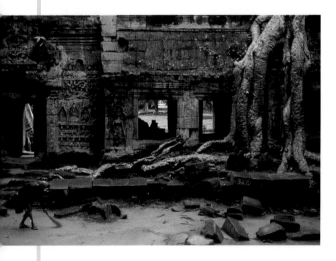

Wet weather

During the wet monsoon, the temples take on a completely different appearance, and the themes are green foliage and grey stone, with moss and vegetation flourishing.

Dry seasons

Early morning and late afternoon during the dry season are the predictable – and admittedly very attractive – times to capture the rich texture and warm colours of the stonework at the temples, and the results have a consistency of colour and atmosphere.

Climate and light

NATURAL LIGHT DEPENDS on weather, which depends in turn on the climate. Travelling makes you more conscious of this, partly because you are likely to be more exposed to outdoor conditions than usual, and partly because you are likely to be in a less familiar climate (this depends, of course, on how far you have travelled). World travel is now so much easier, cheaper and more common, than it was, say, twenty years ago, that more and more photographers are experiencing very different climates on their trips. This is the logic behind spending time here looking at

the photographic effects of the world's climates. Light makes such a tremendous difference to a shoot that there is every argument for planning the timing of a trip to give yourself the best lighting opportunities. There are a dozen major climatic zones (including mountains as one) according to the standard classification, but of course there are rarely sharp divides between them. Microclimates also add variety.

Although I'm stressing the effect that climates have on light, there is also sometimes the more practical matter of

KEY	Colour	Precipitation	Temperature and conditions
Arctic		None	Cold
Subartic		Snow	Very cold, permafrost
Cold, snowy		Rain/Snow	Below -3°C in winter
Temperate		Seasonal	Above -3°C in winter
Mountain		Various	Altitude dependent
Dry		Below 25cm/year	Hot or cold
Tropical		Heavy	Rainfall heavy, often all year

accessibility. Climates that have extreme seasons may also make it difficult to get around, particularly in less developed countries. The wet season in a monsoonal country like Cambodia, for example, turns most of the roads to mud, and this drastically restricts the areas of the country that can be visited. The summer in the Sudan brings the possibility of the haboob, a huge, sudden duststorm that can travel at speeds of up to 50mph with a front wall of up to 915m (3,000ft). The onset of winter in the Himalayas closes passes. An extreme case, for example, is Mount Kailash in western Tibet. There are two 'windows' in the year for shooting, one in May, the other in September, and while they can vary in

length and exact timing, the highest reliability for clear views is just two weeks each. In winter the route is dangerous and the high passes snowbound, while summer is cloudy over the peak. These kinds of climatic detail call for very specific research; use the climate maps and descriptions that follow as an introduction and general guide, but for your exact destination do the in-depth research described on pages 86–87.

Finally, the issue of comfort. Shooting outdoors at 40°C is no joke, and will slow most people down. Very low temperatures also take up time and energy – removing gloves, unzipping jackets, avoiding frostbite. Remember to factor this in.

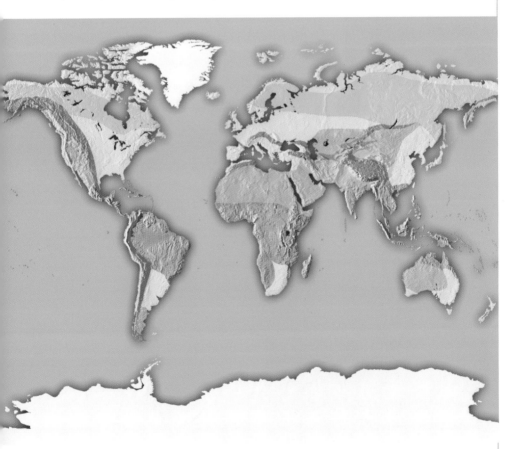

Tropical light

Tropical wet

Monotonous and sultry, with no seasons and little variation in the heat and rainfall, both high. Never cool, and while average temperatures are around 26°C, it feels hotter and more enervating because of the high humidity. Most of the rainfall is convectional, typically late in the afternoon as thunderstorms, with squalls. Often cloudy, but mornings start off bright.

Examples: the Amazon, Borneo, New Guinea.
Lighting issues: Sun intense when it appears. Probability of sunrises, and sunsets if there has been a late-afternoon thunderstorm to clear the air. Midday sun overhead and difficult for shooting. Rains heavy but usually brief. Spectacular cloud formations from convectional rain.
Equipment issues: High heat and humidity potentially damaging. Heavy rains demand very good protection (see pages 60–63, Protection from heat and dust, Protection from water).

Irian Jaya
Equatorial climate is not all rain, even if hot and sticky. Early and late, as here in the Baliem Valley, the light can be rich and the cloud formations often piled high.

Borneo
Midday sun on the equator is harsh, and in shaded locations like this, the contrast is so high that inevitable shadow details are lost.

Surinam
A village ceremony in the interior of this South American country, typically overcast but much brighter than equivalent weather in a temperate climate.

Tropical monsoon

A variation on Tropical wet in that rainfall is concentrated in one definite season, the monsoon, which often breaks on one particular day. There are commonly three seasons: rainy (during which there are still some drier, sunny periods), followed by cool dry, which gradually changes into hot dry.

Examples: Indo-China, most of India.

Lighting issues: Seasonality makes the timing of a trip critical. Best sunshine is immediately following the monsoon, but skies can be unremittingly blue and therefore ultimately boring. The dry period before the monsoons can be hazy. How heavy and continuous the monsoon rains are depends on the region.

Equipment issues: For the rainy season, see opposite (Tropical wet). The end of the dry season can be very hot (see pages 60-61, Protection from heat and dust).

Kerala
The wet monsoon is typical of this climate zone – uncomfortable to shoot in but great for the lush, waterlogged greenery.

Burma
As the dry season progresses, temperatures rise and haze increases, which gives opportunities for attractive backlighting early and late, as in this scene of farmers loading hay near Mandalay.

Thailand
The more familiar light is the clear, often cloudless skies of the dry monsoon in the cool season – crisp in the early morning and late afternoon, but with a certain monotony of blue sky.

Light in dry climates

Savannah

Another tropical climate, with less overall rainfall than the previous two, and a long, distinctly dry season. These conditions result in large areas of grassland instead of forest. A rainy season is followed by cool dry, becoming hot dry.

Examples: East Africa, the Guiana Highlands.

Lighting issues: Dry season is light, bright and clear, with particularly good visibility in upland areas like East Africa. Rainy season offers variable light, not as heavily overcast as in Tropical monsoon regions.

Equipment issues: Dust is the main problem in the dry season (see pages 60–61, Protection from heat and dust).

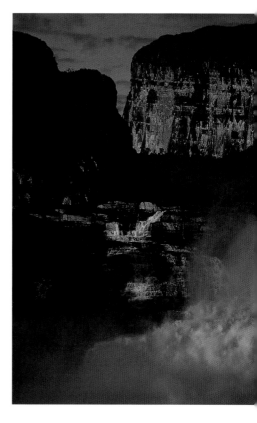

Guiana Highlands
The high savannah of southern Venezuela in May, which is the start of the hot season (although the height of the base plateau at around 1,500m (4,900ft) keeps the temperatures bearable). Generally clear skies, and dry.

South Africa
Rhino capture in the Pilanesberg National Park, near Sun City, South Africa. May in the southern hemisphere is winter, and at over 1,000m (3,300ft) this plateau area is crisp, cool, and dry. High UV-content gives shadows and distances a bluish cast.

Semi-arid steppe

A dry climate with low, irregular, and undependable rainfall. Drought years are interspersed with years of moderate rain, but hard to predict. In the tropics summers are hot, winters cool, but further north, as in the Asian steppes, the temperature range is greater, with hot summers and cold winters. Rainfall distribution by month varies from region to region, but is always unreliable.

Examples: Afghanistan, northern New Mexico.
Lighting issues: High percentage of clear skies, and in the driest season often no cloud for days at a time.
Equipment issues: Needs protection against dust (see pages 60-61, Protection from heat and dust).

New Mexico
Dry conditions predominate in the southwest, as here in Santa Fe, New Mexico, and clear, bright days are predictable for much of the year, accounting for its long popularity with painters and photographers.

Desert

Rainfall is usually less than 25cm (10in), and in extreme places like the Atacama in northern Chile there may be no rain at all for years on end. Very reliable sunshine, and so great temperature variation from day (very hot) to night (cool to cold). Duststorms possible, and in some desert areas these are seasonal and sometimes predictable. Coastal deserts experience fog, mist, and sometimes low cloud.

Examples: the Sahara, Namibia.
Lighting issues: Intense sun, blue skies. Early mornings and afternoons are key times for outside shooting (see pages 156–157, Deserts).
Equipment issues:
Extremes of heat and dust. Very sharp drop in temperature at night can cause condensation problems (see pages 60–61, Protection from heat and dust).

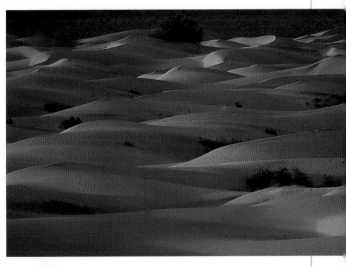

Death Valley
Below sea level at some points, Death Valley in California experiences an average of 5cm (2in) of rain a year and the highest mean temperatures in the US (and the highest record of 56.7°C). It has four areas of sand dune.

Mid-latitude light

Mediterranean

Probably the most comfortable, attractive climate for general photography. Rainfall is low and concentrated in the mild winter season, leaving the summers bright, sunny, and warm-to-hot. Some coastal locations, like San Francisco, have cool summers and significant fog in the mornings.

Examples: the Mediterranean coast, central California.
Lighting issues: High sunshine percentage and high reliability. Easy to schedule shooting in advance.
Equipment issues: No special problems.

Aegean
A whitewashed Greek church against an intense blue sky on the island of Mykonos is archetypical of the Mediterranean ideal.

New Orleans
Hot, steamy, but bright – early morning in the French Quarter of New Orleans on the Mississippi.

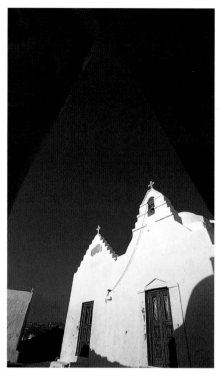

Humid subtropical

Cool winters, hot summers, with moderately high rainfall that is either throughout the year or concentrated in part of the summer. High summer humidity makes the height of this season uncomfortable and muggy. Liable to hurricanes and typhoons (same thing, different name) in late summer and early autumn.

Examples: the US Gulf States, central and southern Japan.
Lighting issues: Variety of lighting conditions, low-to-moderate predictability.
Equipment issues: In summer, heat and humidity can be as high as in Tropical wet regions.

Marine

Summers cool to warm, winters never very cold. Rainfall is fairly high but varies greatly from region to region, spread across the year but less in the summer. Unpredictability of everything is characteristic, and for photography this can be difficult. Weather is dominated by air coming in off the ocean, more often than not as depressions.

Examples: Western Europe, Vancouver, Washington State.
Lighting issues: Highly variable weather and difficult to predict. The light can change even several times in one day. Distance from equator causes a strong seasonal difference in the height of the sun and the length of the day.
Equipment issues: No special problems.

Continental

Severe differences in temperature between the seasons, with warm-to-hot summers and cold winters – annual temperature ranges of around 10°C are common. Precipitation across the year with a summer maximum; many snow-covered days in the winter.

Examples: the continental US, central Europe.
Lighting issues: Length of daylight and height of the sun are similar to marine climates. Conditions moderately predictable.
Equipment issues: Severe winters can give subarctic conditions (see pages 58–59, Protection from cold).

England
While the English weather is actually very varied, a blustery day like this, with a mixture of sunshine and showers, is widely considered typical.

Western Europe
The type of weather that draws the most complaints in marine climates like that of Western Europe is overcast, when depressions arriving from a long sea crossing can bring day after day of featureless, grey light.

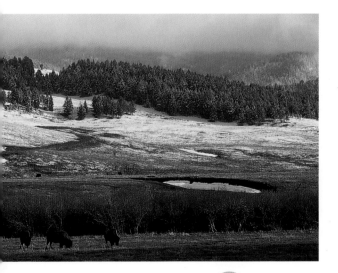

Montana
Extremes of temperature are the hallmark of continental locations, far from the ocean. At one end of the scale is winter – cold and uncompromising – as here on the Turner Ranch in Montana.

Arctic and mountain light

Subarctic

Huge area of the Earth's surface but very small population. Long, bitterly cold winters, very short summers, brief spring and fall. Summer days are long, winter very short. Low precipitation concentrated in warmer months, but long-lasting snow cover in winter.

Examples: the Russian taiga, much of Canada and Alaska.
Lighting issues: Very long daylight hours in summer allows extended shooting, but very short days in winter are restrictive. The sun is never high, so clear weather very attractive. As with Arctic regions, possibility of aurora borealis.
Equipment issues: Cold and condensation are the main problems (see pages 58–59, Protection from cold).

Arctic and Antarctic

Never warm and the winters are bitterly cold. The main feature for photography is continuous light in summer and continuous darkness in winter. Tundra is the part bordering the ice caps.

Examples: Greenland, Antarctica.
Lighting issues: By definition, winters are essentially one long night, although one special feature is the aurora borealis. Summer days move from one long sunrise to one slow sunset, with the sun's path travelling around the horizon.
Equipment issues: Severely cold (see pages 58–59, Protection from cold).

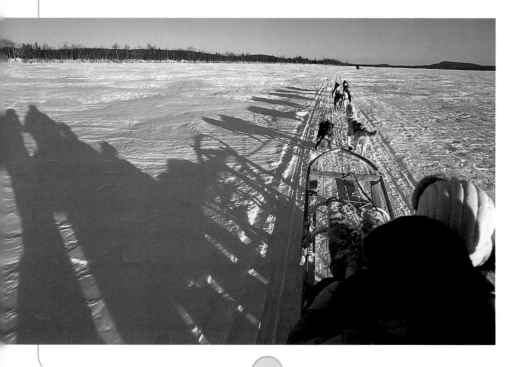

Mountain

Mountains intrude so much into the surrounding climates that they create their own general group of climates. It varies greatly, and in any one region is arranged vertically. As a rule of thumb, above about 3,000m (5,000ft), mountains create their own climates. It is difficult to generalize, but characteristics are low pressure, high UV and intense sunlight, high contrast in both light and temperature between sun and shade. Thin air gives a high range of temperature from day to night, also. Precipitation is often higher than in the surrounding lowlands because the mountains cause air to rise and lose its capacity to hold moisture. Often this is on the windward side only, while the lee stays drier. There may be special mountain and valley winds.

Himalayas
At 5,000m (16,400ft), the visibility in fine weather is exceptionally good – the atmosphere is thinner than at sea-level, with 50% of the oxygen. The strong blues are due to the correspondingly high UV content.

Examples: the Rockies, the Himalayas.
Lighting issues: High altitude means strong UV and so blue distances and shadows. Thin air gives high contrast in sunlight, so expose for lit areas, not shadows. Weather often unpredictable, so light can change rapidly according to cloud cover (see pages 154–155, Mountain trekking).
Equipment issues: Physical protection against knocks is a priority, particularly when climbing is involved. High altitude means possibility of cold and condensation problems, especially at night (see pages 58–59, Protection from cold).

Lapland
The winter of northern Sweden is characterized by snow cover and Arctic conditions – sometimes as benign as this clear afternoon from a dogsled.

Himalayas
Weather, light, and temperature shifts can be rapid and distinct at these altitudes (here, also in western Tibet as above, at 6,000m/19,700ft). Clouds passing in front of the sun change the lighting more dramatically than at sea-level because of the greater difference between light and shade.

Daylight tables

PREDICTING THE SUN ON THE HORIZON

Rising and setting suns may be well-worn and overshot images, but occasionally they are needed, particularly if the horizon has something interesting to show, such as a gap between mountain peaks or a building. In such a case, where you need precision, it is essential to know in advance where on the horizon the sun will appear in the morning or disappear in the late afternoon. There is another reason for predicting the position of the sun at these times – when it casts a shadow over part of a scene, and how that shadow will move. Only within the tropics does the sun ever rise and set vertically. At higher latitudes its track is diagonal (in an Arctic and Antarctic summer it appears to go around the sky almost horizontally). The graph below shows the rough path the sun takes at different distances from the equator (the higher point of each shaded zone is midsummer, the low being winter). Obviously, the more difficult to predict is sunrise, but you will notice the predawn glow gradually move sideways. A sensible precaution is to scout out more than one camera position so that you can move quickly to one side or the other at the last moment.

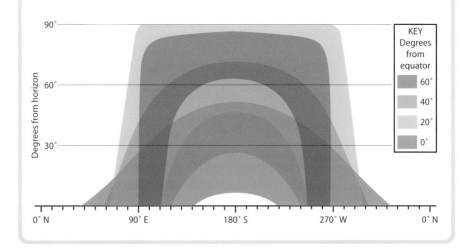

KEY
Degrees from equator
60°
40°
20°
0°

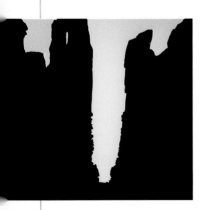

Bear and Rabbit Rocks

Planning the camera position was crucial for this shot of a well-known rock formation in Monument Valley. I wanted the sun to appear exactly in the notch as it rose, which meant judging the angle at which it appeared to rise from about half an hour before – from lower left to upper right. In other words, the glow before sunrise was left of the actual sunrise.

NORTHERN VS. SOUTHERN HEMISPHERE

Some people have difficulty conceptualizing this, but the track of the sun is from left to right in the northern hemisphere, yet right to left in the southern hemisphere. Most of the Earth's population, including photographers, is in the north, so the confusion normally begins on a trip to Australia, southern Africa, and the south of South America. In the north we're used to facing south to see the sun, so it appears to rise on the left and set on the right. In the southern hemisphere it's the opposite – face north to see the sun. Major confusion is likely when you are expecting sunrise at a particular point on the horizon.

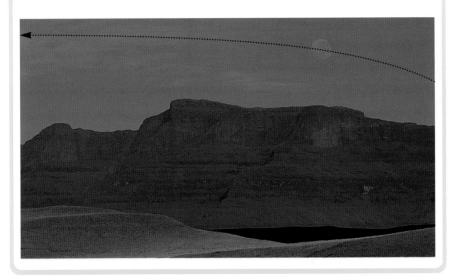

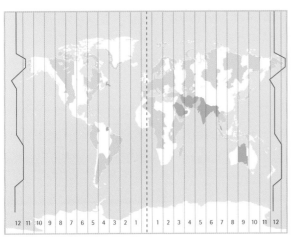

Hours behind GMT < **GMT** > *Hours ahead of GMT*

☐ Even numbered hours from GMT
▨ Odd numbered hours from GMT
■ Varies from relevant time zone

Drakensberg
Moonrise in Natal, South Africa. As with sunrise, the apparent movement from lower right to upper left can be confusing for anyone from the northern Hemisphere.

GMT
It is useful to keep in mind a sense of the time zone in which you are travelling. This map should help you plot where you are in relation to other time zones.

Camera choices

Aᶠᵀᴱᴿ ᵀʜᴱ ᶠᴵᴿˢᵀ ᶠᴸᵁᴿᴿʸ of experimentation among manufacturers, the range of digital cameras has settled down to three basic types suitable for travelling (I exclude backs for medium- and large-format cameras). They are:

- Compacts
- Prosumer models
- SLRs

The big change that digital photography has brought to selecting equipment is that the image quality is no longer standardized. It depends on many variables, including the CCD size, density and distribution of the individual photo-sensors, interpolation methods, the camera's firmware, and your choice of level of compression. And more. The right equipment for travel depends ultimately on the use you intend to make of the finished images.

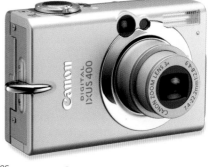

Canon Digital IXUS 400
Digital IXUS 400 is a fully featured, beautifully styled camera with new super-hard cerabrite finish, and featuring a four megapixel CCD.

The main issue is still resolution, on which the number of megapixels has the biggest impact. Crudely put, if you intend to publish your images, you will need high resolution, which means at least 6 megapixels. Compact models will not meet this requirement. In the days of film, a light compact camera with very few features could still be a useful addition to the photographer's baggage – ideal for quick, surreptitious shooting, and for carrying around in the evening. The film was the same. At this point in digital photography, however, manufacturers have not yet seen the need for a high-resolution small camera. It may happen in the future. On the other hand, if your demands are more personal, there is no point spending extra money on a top-of-the-line camera.

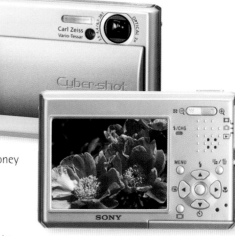

Fixed-lens prosumer models are, in relation to traditional SLRs, light and compact, considerable advantages for travelling. The better models have resolution good enough for publishable images up to 20x28cm, while covering a good range of focal lengths with their zoom. Designs vary, although the top models are now converging on the asymmetrical right-hand grip style.

Sony Cybershot DSC-T1
The ultra-slim Cybershot DSC-T1 comes with a three times optical zoom coupled with a five megapixel sensor.

SLRs tend to be more rugged (higher build quality), offer a smoother transition for photographers accustomed to film SLRs, and accept a wide range of lenses (a major consideration if you already own a valuable set). All major camera manufacturers have, or are about to have, a digital SLR at the top end of their range. Weight is, nevertheless, an important consideration when travelling, and the difference between a fixed-lens digital camera and an SLR is considerable.

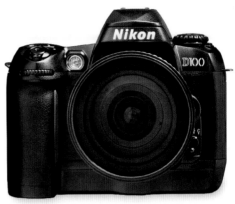

Nikon D100
This 6.3-megapixel camera brings beautiful images to life with unsurpassed sharpness, contrasts, colour richness, and crisp detail.

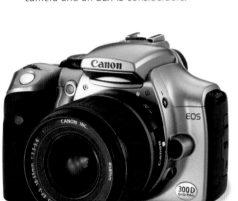

Canon EOS-300D
Optical Sensor Resolution: 6.3 megapixel CCD, which is a silicon chip at the heart of every digital camera. 6.3-megapixel will offer you sharp, professional quality.

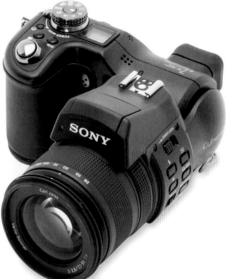

Sony Cybershot DSC-F828
This is a formidable prosumer camera with a high quality mechanically linked zoom lens combined with the resolution of an eight megapixel CCD.

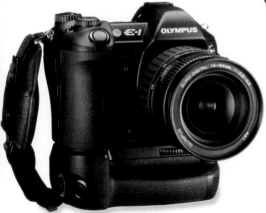

Olympus E-1
Unlike digital cameras with film lenses and accessories attached, every component of the E-1 was designed to be digital.

Compact travel kit

IN THIS CONFIGURATION, the camera is a simple design, but the trip planned is abroad for a few weeks. Special considerations are mains power for the battery charger and downloading images from the memory cards. It would be expensive to carry enough spare cards for a long trip, and estimates of how much you will shoot are likely to be out. There are several solutions, but this attractive, if expensive, alternative is to carry a laptop, along with other lightweight accessories.

Waterproof case
One of the few dedicated accessories for the camera, good for all bad weather conditions including dust storms, and waterproof to 3m (10ft). Comes with silicone grease for the waterproof seal and anti-condensation solution for rapid temperature changes.

Laptop
In this case, a small Sony Vaio Picturebook with ample storage space on its 20GB hard drive. Already loaded with camera, browser, database, and image-editing software.

Connection cable
Either a USB or Firewire cable for downloading images from camera to computer, and for shooting directly from the computer.

Mini-tripod
Looks dinky, but this Gilux model with a Leica ball-and-socket head is surprisingly robust. Weight 430g (15oz) and it is not designed to be used from ground level, but from a variety of solid surfaces.

Swiss Army knife
Versatile tool kit, useful for the unexpected. Warning: do NOT keep in hand baggage on any flight, or it will be confiscated.

Spare battery
You should check the average time that a battery lasts on a full charge for the way you use it. Add at least one spare, more if you shoot heavily between recharge times.

Spare memory cards
Essentially a matter of cost. Higher megabyte storage is always more useful. The number and capacity of each depends on how you shoot, and how often you intend to download.

Cellphone
Can be used with the laptop to upload images to the user's email address or website.

Camera
A Canon Ixus, sturdy construction in steel. Compact design, largely automatic, medium-resolution capable of delivering half-page images. Self-installing software that needs little user attention.

Shoulder bag
Small, unfussy design by one of the first manufacturers of modern-style camera bags, Domke. Lightweight, strong, steel clips, nothing to go wrong.

Modem cable
Don't rely on being able to use local telephone cables. With adaptor depending on countries being visited.

Receipt photocopy
As a customs precaution, photocopy the receipts for all valuable equipment.

Notebook and pen
Travel, unless to a single destination, usually involves high information input. Knowing what you shot and where is essential.

Laptop power accessories

Manual
Until you are completely familiar with the camera, pack it. An alternative is to download a PDF version from the manufacturer's website, if available, and store this onto the software disk.

Blower
For dust removal. Travelling exposes cameras to all kinds of airborne particles. Use once a day at least.

Plug adaptor
The straightforward power supply option for travelling abroad. Use in conjunction with the tables on pages 66–67.

Spare software
For computer safety, record copies of the camera software (and any other that is important) onto a CD.

Battery charger
This camera uses specially designed rechargeable batteries. The plug fitting depends on the country of purchase.

Prosumer travel kit

THIS KIT IS BASED ON a top-of-the-line prosumer model, a Fujifilm FinePix S7000 weighing 500g (17.6oz). For its features, which include a 7.8–46.8mm 6X zoom lens (equivalent to 35–210mm on a 35mm camera), and a 6.6-megapixel sensor, this design is remarkably compact. Most major manufacturers have an equivalent. As an alternative to a laptop computer, bulk storage for the images is in the form of a portable device designed specifically for digital photography.

Memory cards
As with any digital camera, the combined storage capacity, in MB, should be sufficient for what you expect to shoot between downloads to the storage device at right. A wallet is useful for organizing them.

Prosumer camera
Standard design for high-performance models is now asymmetric, with the lens on the left and a pronounced hand-grip on the right.

Memory card reader
A quicker way of transferring your data.

Cable release
Not all digital cameras accept these, but for time exposures it removes the risk of camera shake. Use with the small tripod opposite.

Spare batteries
These depend naturally on the camera design – in this case standard AA batteries, which have the advantage of being on sale everywhere and not needing a charger, but the disadvantage of a shorter life than customized Li-Ni.

USB cable
It's always important to have the cable to connect your camera to a computer.

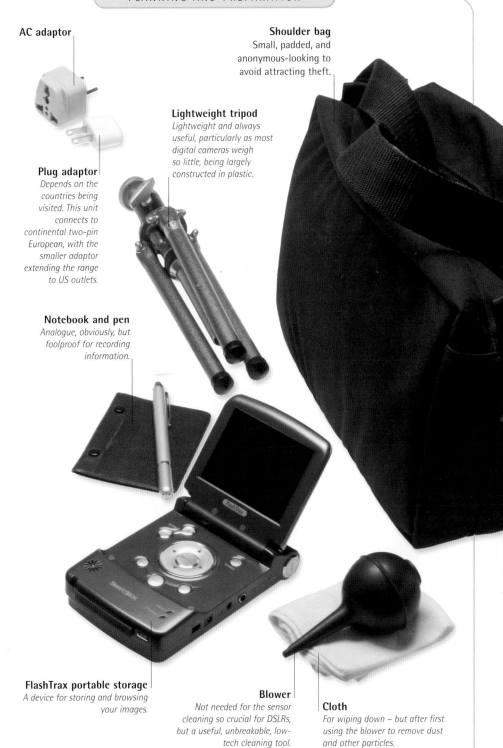

AC adaptor

Shoulder bag
Small, padded, and anonymous-looking to avoid attracting theft.

Lightweight tripod
Lightweight and always useful, particularly as most digital cameras weigh so little, being largely constructed in plastic.

Plug adaptor
Depends on the countries being visited. This unit connects to continental two-pin European, with the smaller adaptor extending the range to US outlets.

Notebook and pen
Analogue, obviously, but foolproof for recording information.

FlashTrax portable storage
A device for storing and browsing your images.

Blower
Not needed for the sensor cleaning so crucial for DSLRs, but a useful, unbreakable, low-tech cleaning tool.

Cloth
For wiping down – but after first using the blower to remove dust and other particles.

SLR travel kit

THIS PACKING ARRANGEMENT is for transportation rather than shooting (see page 41 for the stripped-down kit that goes in a shoulder bag), hence the robust, solid case. Nevertheless, the dimensions of the case are within airline regulations for carry-on baggage. The less delicate, less valuable, and nonessential items shown here, and marked with * will be packed in the checked luggage.

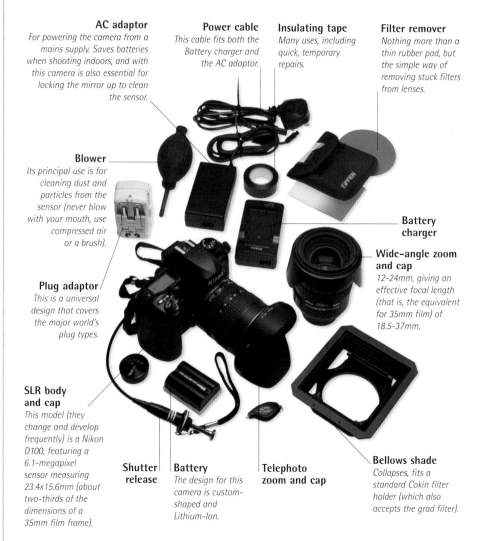

AC adaptor
For powering the camera from a mains supply. Saves batteries when shooting indoors, and with this camera is also essential for locking the mirror up to clean the sensor.

Power cable
This cable fits both the Battery charger and the AC adaptor.

Insulating tape
Many uses, including quick, temporary repairs.

Filter remover
Nothing more than a thin rubber pad, but the simple way of removing stuck filters from lenses.

Blower
Its principal use is for cleaning dust and particles from the sensor (never blow with your mouth, use compressed air or a brush).

Plug adaptor
This is a universal design that covers the major world's plug types.

Battery charger

Wide-angle zoom and cap
12-24mm, giving an effective focal length (that is, the equivalent for 35mm film) of 18.5-37mm.

SLR body and cap
This model (they change and develop frequently) is a Nikon D100, featuring a 6.1-megapixel sensor measuring 23.4x15.6mm (about two-thirds of the dimensions of a 35mm film frame).

Shutter release

Battery
The design for this camera is custom-shaped and Lithium-Ion.

Telephoto zoom and cap

Bellows shade
Collapses, fits a standard Cokin filter holder (which also accepts the grad filter).

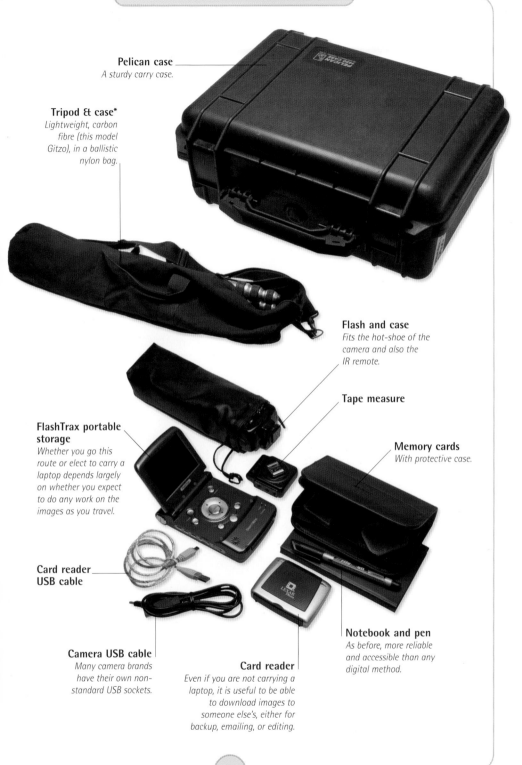

Pelican case
A sturdy carry case.

Tripod & case*
Lightweight, carbon fibre (this model Gitzo), in a ballistic nylon bag.

Flash and case
Fits the hot-shoe of the camera and also the IR remote.

Tape measure

FlashTrax portable storage
Whether you go this route or elect to carry a laptop depends largely on whether you expect to do any work on the images as you travel.

Memory cards
With protective case.

Card reader USB cable

Camera USB cable
Many camera brands have their own non-standard USB sockets.

Card reader
Even if you are not carrying a laptop, it is useful to be able to download images to someone else's, either for backup, emailing, or editing.

Notebook and pen
As before, more reliable and accessible than any digital method.

SLR Trekking backpack

Weighing 12kg (26lb), this is no lightweight configuration, but it is the right solution for a serious walk in the hills. Downloading images to the computer and uploading them to servers are ignored here – this is a self-contained operation. Any editing other than basic, on-the-spot review and delete will be done on the return to base at the end of the day. If the trek involves overnight camping for two or three days, the number of spare batteries and memory cards will have to be worked out very carefully from your own experience of how you shoot. Needless to say, halfway up Helvellyn or on a trans-Himalayan pass is not the place to run out of either of these.

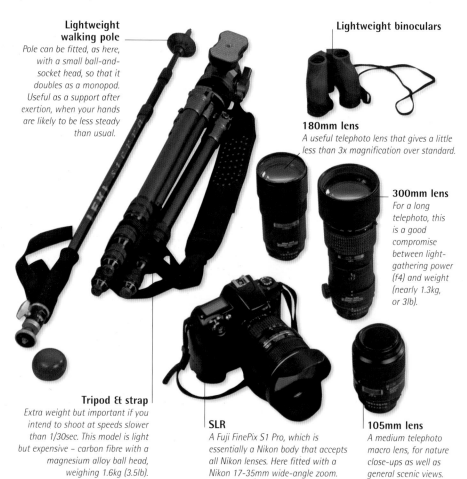

Lightweight walking pole
Pole can be fitted, as here, with a small ball-and-socket head, so that it doubles as a monopod. Useful as a support after exertion, when your hands are likely to be less steady than usual.

Lightweight binoculars

180mm lens
A useful telephoto lens that gives a little less than 3x magnification over standard.

300mm lens
For a long telephoto, this is a good compromise between light-gathering power (f4) and weight (nearly 1.3kg, or 3lb).

Tripod & strap
Extra weight but important if you intend to shoot at speeds slower than 1/30sec. This model is light but expensive – carbon fibre with a magnesium alloy ball head, weighing 1.6kg (3.5lb).

SLR
A Fuji FinePix S1 Pro, which is essentially a Nikon body that accepts all Nikon lenses. Here fitted with a Nikon 17-35mm wide-angle zoom.

105mm lens
A medium telephoto macro lens, for nature close-ups as well as general scenic views.

Backpack
The camera versions like this are annoyingly more expensive than regular backpacks, but they do the job well, with compartments, adequate padding, and room for awkward items like a tripod.

Spare batteries
According to experience, but more than anticipated.

Karabiner
A climbing accessory that doubles for securing the backpack.

Water bottle

Spare memory cards
Number and capacity based on experience. These are high-capacity microdrives.

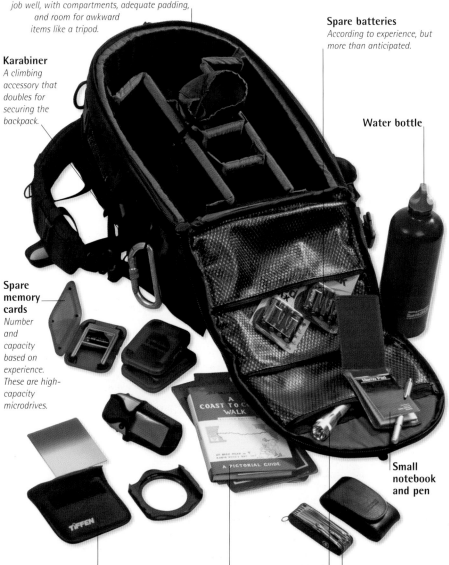

Small notebook and pen

Filter holder and grad
Neutral grad filter for darkening skies, needs a holder which allows it to be moved up and down, and rotated. Adaptor rings for fitting to various lens diameters.

Wainwright and map
Trekking guide and map. In this case, for a walk across England from the Lake District, the famous hand-drawn, hand-written Wainwright Coast to Coast.

Torch
Lightweight, rugged, twist-top operated.

Swiss army knife
All-in-one emergency small tool.

Tripods and supports

M OST PHOTOGRAPHERS have mixed feelings about tripods. On the one hand they are undeniably useful in adding to the range of images you can get on a trip. Indeed, they are essential for interiors, night-time views, and long, heavy lenses, as well as experimental techniques such as deliberately blurred movement from time exposures and deep-focus shots with a telephoto. On the other hand, they weigh extra, are not much fun, and slow down the pace of shooting. How much more pleasant and looser to simply walk and shoot handheld.

Travel for even a few days, however, increases the chance that you may need a tripod, and most photographers planning a long trip will at least take a tripod along, even if it stays in the vehicle or hotel room for most of the time. In choosing a tripod, the essential point is that it must be steady enough for the job, which sounds too obvious. However, weight and bulk are the penalty with tripods, and no-one wants to carry more than is necessary. Just as there is no point in even considering a lightweight tripod that is too flimsy to hold the camera firmly (or too short for normal use), neither is there any reason to have a tripod that is overspecified for a small camera.

Tripod efficiency depends on two things: design and materials. The first essential quality for any tripod, as for any bridge, is that it stays firm and still under average conditions. The acid test is to fix your camera, set the zoom lens to its longest focal length (or attach the longest lens you normally use if an SLR), and tap the front of the lens while looking through the viewfinder or at the LCD. Common sense will show whether the slight vibration is acceptable, but, to make sure, shoot a few times at around 1/60sec to 1/125sec while tapping the lens. Full-size viewing on the LCD screen may not reveal camera shake, and to be completely certain open the images on the computer at 100% magnification. Torsion is another indication of tripod stability – with the camera detached, grasp the head firmly and try to twist it clockwise and counter-clockwise. There should be no significant movement. Note that

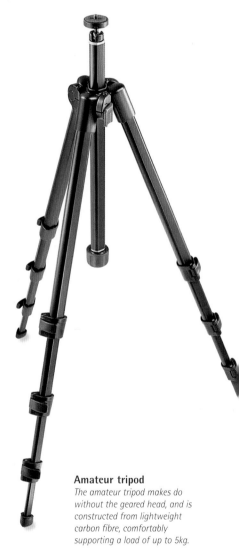

Amateur tripod
The amateur tripod makes do without the geared head, and is constructed from lightweight carbon fibre, comfortably supporting a load of up to 5kg.

Professional tripod
This tripod is constructed of sturdy anodized aluminum and Manfrotto's centre-brace struts that allow evenly or individually angled legs.

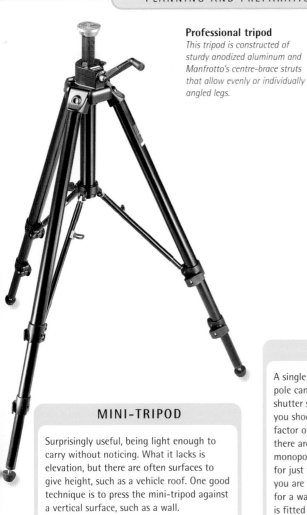

Car roof
You can use the top of a car (with the engine off) as a tripod stand. This not only gives you a firm foundation, but lets you see over tall hedgerows.

MONOPOD

A single adjustable pole can improve the shutter speed at which you shoot by about a factor of two, and there are numerous monopods available for just this purpose. If you are trekking, look for a walking pole that is fitted with a 9mm (⅜in) screw that will accept a small tripod head: two items in one cuts down on your packing and the weight you're carrying. A monopod is also potentially useful in situations where you're facing restrictions on the use of tripods (see page 118).

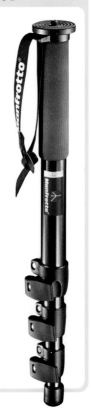

MINI-TRIPOD

Surprisingly useful, being light enough to carry without noticing. What it lacks is elevation, but there are often surfaces to give height, such as a vehicle roof. One good technique is to press the mini-tripod against a vertical surface, such as a wall.

centre-pole extensions can, if not very well built, reduce stability. This is particularly true of rack-and-pinion movements operated by a rotating lever; convenient, but not necessarily solid.

Tripod heads are as important as the tripod. A weak head will destroy any advantage you have from a strong tripod. There are two designs: pan-and-tilt, and ball-and-socket, which allows full play in every direction with one unlocking movement. Which is better is entirely a personal choice.

Cost enters the equation for travel, because strong, light materials are available and they are always more expensive. The material of choice for tripods is carbon fibre (30% lighter than aluminum, and more rigid), and for heads magnesium alloy (with a specific gravity of 1.7 this is two-thirds the weight of aluminum and one-quarter the weight of steel), but the price difference from standard is considerable. For all the above choices, if you are buying a tripod and head, compare models side by side for shake, torsion, weight, etc.

Finally, there are good impromptu alternatives to tripods, depending on how slow a shutter speed you need. To hold the camera more steadily, a rolled-up cloth or soft camera bag on a solid surface (such as a wall) works very well – if you press down on the camera or lens as you shoot, you may be able to use shutter speeds as slow as one second. Long exposures are possible with an electronic cable release; find a surface at a workable height, prop the camera up with whatever is handy, and trigger the release. To avoid uncertainty, shoot several shots in these conditions.

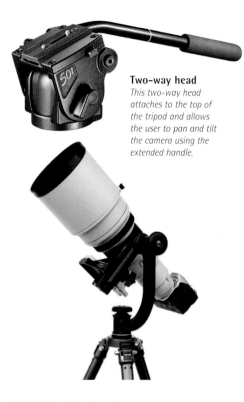

Two-way head
This two-way head attaches to the top of the tripod and allows the user to pan and tilt the camera using the extended handle.

Gimbal head for long lenses
The problem with very long lenses, which are inevitably heavy and massive (because of the front lens diameter), is locating their centre of gravity close to the axis of the tripod head. One specialized solution is a gimbal head, the most well-known of which is manufactured by Wimberley. This attaches to the rotation collar of the lens, as shown.

TRIPOD MANAGEMENT

- A lower position is more stable than a higher one, so avoid unnecessarily elevating the platform.
- Make sure that the surface is steady. Sand shifts, as do loose wooden floorboards.
- Adjust the legs so that the platform (immediately below the tripod head) is level. Do not level by the tripod head alone.
- With a long lens on an SLR, use its tripod bush rather than that of the camera, in order to get closer to the centre of gravity. If you use very heavy lenses, invest in a gimbal head like the one shown.
- Shelter the tripod from the wind.
- If you are likely to want to remove the camera in a hurry, ensure you have a quick-release platform on your head.

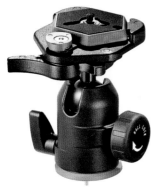

THE DANGEROUS SPEEDS

Fast shutter speeds don't need a tripod, and at very slow speeds, such as a second or longer, the camera has time to settle down after the shutter is released. Moderately slow speeds, however, such as 1/30sec and 1/15sec, can produce camera shake with a long focal length even on a tripod. Check for this.

Ball head
The ball head can be adjusted to any angle, then fixed in place by turning the knob. The built-in level can be used to set it evenly.

FOCAL LENGTH AND CAMERA SHAKE

Camera shake is the condition that tripods and other supports are intended to correct, and its symptoms are as shown here – blur of a characteristic, 'doubled' kind across the entire image. What counts is not absolute movement, but the movement of the image, and as long focal lengths magnify images, they also magnify shake. Long focal-length lenses (for SLRs) also tend to be heavy, which can be an advantage on a tripod as the weight makes the setup more solid, provided that you mount the lens near its centre of gravity (use the lens's own tripod bush).

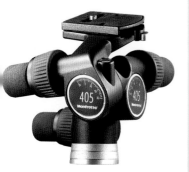

Three-way head
The three-way head has three separately adjustable joints, allowing accurate positioning at angles. This model also features a quick-release camera platform.

ANTI-SHAKE TECHNOLOGY

There are two technologies for reducing camera shake that can be built into the camera or lens. One is electronic image stabilization, commonly used in camcorders and also in some still digital cameras. In this, the camera's processor judges how much the image in the frame is moving, then compensates by digitally 'moving' the image. The disadvantages are that it adds a time lag to shooting, and interferes with panning. The second, better method is a motion sensor that detects movement and a motor that introduces minute compensatory movement. Nikon's VR technology, for example, distinguishes between large movements, such as panning, and shake. It is claimed to improve the shutter speed at which you can shoot handheld by approximately three times.

Camera accessories

REPAIRS AND PROBLEMS

If you are shooting in or near any reasonable-sized city, there is likely to be a choice of dealers, repair shops, and even manufacturers' customer service points. Contact your camera's manufacturer in advance for this information; you can also do an Internet search by typing an entry such as 'camera repair seattle'. One site that gives worldwide coverage is: ACE Indexes www.acecam.com

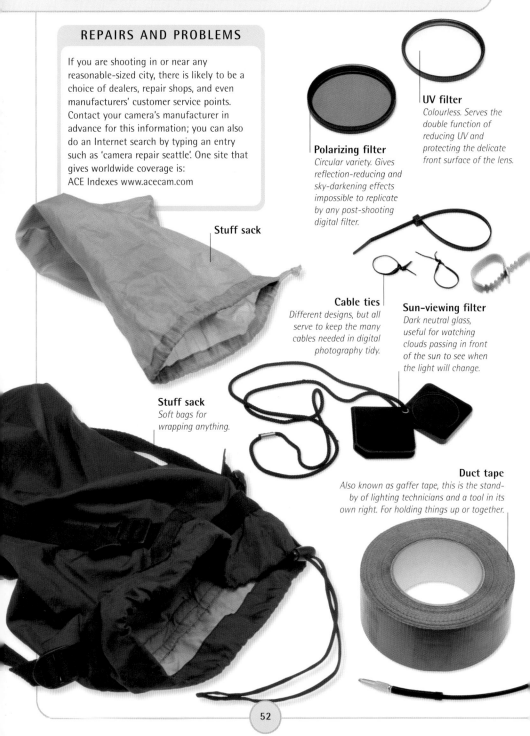

UV filter
Colourless. Serves the double function of reducing UV and protecting the delicate front surface of the lens.

Polarizing filter
Circular variety. Gives reflection-reducing and sky-darkening effects impossible to replicate by any post-shooting digital filter.

Stuff sack

Cable ties
Different designs, but all serve to keep the many cables needed in digital photography tidy.

Sun-viewing filter
Dark neutral glass, useful for watching clouds passing in front of the sun to see when the light will change.

Stuff sack
Soft bags for wrapping anything.

Duct tape
Also known as gaffer tape, this is the stand-by of lighting technicians and a tool in its own right. For holding things up or together.

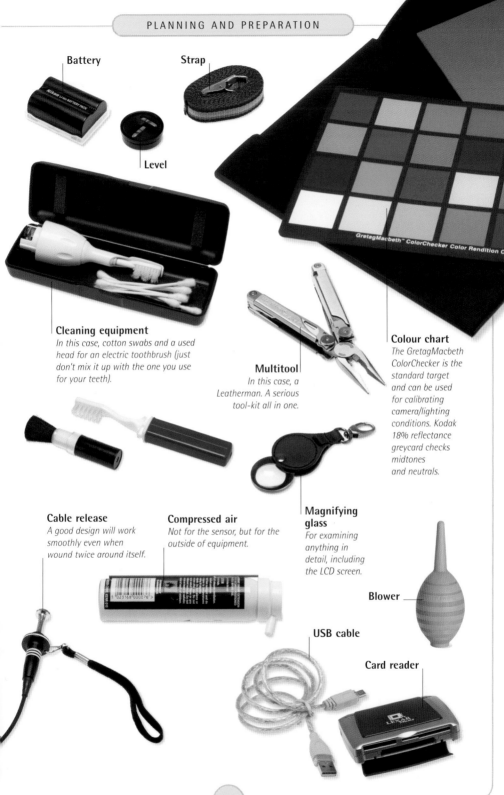

Battery

Strap

Level

Cleaning equipment
In this case, cotton swabs and a used head for an electric toothbrush (just don't mix it up with the one you use for your teeth).

Multitool
In this case, a Leatherman. A serious tool-kit all in one.

Colour chart
The GretagMacbeth ColorChecker is the standard target and can be used for calibrating camera/lighting conditions. Kodak 18% reflectance greycard checks midtones and neutrals.

GretagMacbeth™ ColorChecker Color Rendition Chart

Cable release
A good design will work smoothly even when wound twice around itself.

Compressed air
Not for the sensor, but for the outside of equipment.

Magnifying glass
For examining anything in detail, including the LCD screen.

Blower

USB cable

Card reader

Location lighting

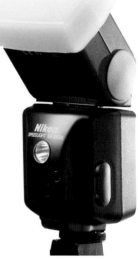

Going beyond the basic on-camera flash to more advanced lighting is a distinct, major step. It supposes a professional need to create special lighting for subjects so as to guarantee results whatever the circumstances, rather than taking a chance on the natural and ambient lighting conditions. Photographic lights, even those designed for travel shown here, add substantially to the bulk and weight (and may push the total packed weight over the 20-kg (44-lb) Economy class limit standard to all airline flights that do not start or end in the Americas). They also slow down shooting considerably – setting up a lit shot takes planning and time.

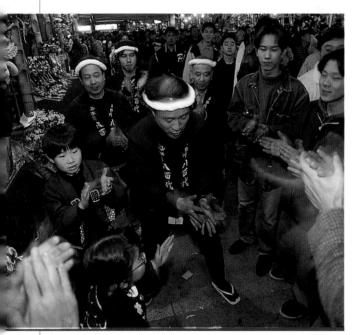

Hot-shoe flash
The first step beyond your camera's built-in flash is the more flexible attachable one, which can be angled off ceilings or other surfaces, or diffused.

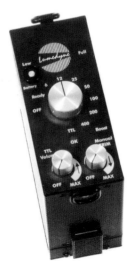

Flash plus ambient
Use a slower shutter speed to capture the ambient lighting – especially with a digital SLR that allows rear-curtain flash. Used at the Tori no Ichi Festival, Tokyo.

Lumedyne power pack
Portable lighting will require power (a battery) and a power pack to control how much power reaches your lights. The Lumedyne system is a popular one.

That said, lighting is virtually essential in some kinds of photography, such as interiors, still-lifes, and certain portraiture styles. If it has to be done, work out the minimum equipment that you can work with, then find the smallest, lightest versions available.

Basic flash

Whether built-in or as a unit attached to the camera's hot-shoe (not all cameras have this connection), on-camera flash can achieve a variety of lighting effects if used knowledgeably. Reducing the output turns it into a supplementary light, brightening foreground subjects, and if the level is adjusted with care the results can be subtle. And digital cameras offer exactly the means to achieve this – instead of hit-or-miss guesswork in the days of film, you can test the effects on the spot.

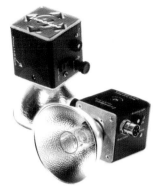

Lumedyne flash
Halogen flashes attach to the power pack (pictured opposite). These portable lights are built for minimum weight, with switchable reflector, snoot, or tube heads.

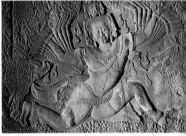

Off-camera flash
Two Norman high-powered portable units were used to illuminate this twelfth-century bas-relief at the temple of Angkor Wat, one a couple of metres to the left of the camera, the other to the right. The lighting angle was essential to reveal the relief of the carving.

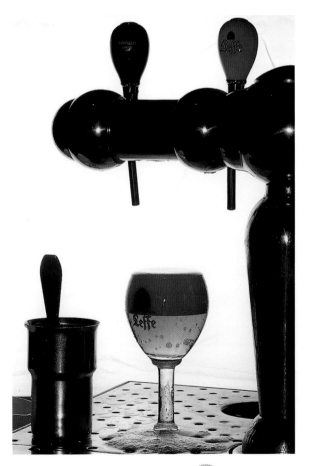

Background flash
For a close-up of a draft beer pump in a Brussels café, a portable flash unit was set up behind a sheet of white cloth to simplify the background. The camera's pop-up flash adds sparkle and definition, and triggers the background flash via its slave cell.

Secondary flash

A step up from on-camera flash is to add a second or third unit, placed at a distance. Instead of triggering by sync cable, spend a little more on a remote trigger, such as the infrared shown opposite (wireless remotes are an alternative, but costlier).

High-powered portable flash

The main drawback with camera-dedicated flash is its low output – adequate for up to a few metres, but not much use for lighting large areas or for firing through diffusers (which absorb a significant amount of light). The alternative is a system based on large rechargeable battery packs.

Incandescent

3,200K incandescent lighting has a great deal going for it. It is highly adaptable. These lights accept both 110-120v and 220-240v lamps, so can be used anywhere. Blue gels on outrig frames bring the colour temperature to that of daylight. They draw AC power, so need mains outlets, or a generator.

Once you have accepted the need for mains-operated lighting, there is no limit to what you can assemble, whether incandescent, flash, or HMI. At this level, however, lighting is the subject of another book.

Stands and supports

These can be the bulkiest part of any lighting kit. Look for lightweight stands (they carry a greater risk of toppling over, however) and also clamps, which are great weight-savers (but use cloths to avoid damage to table and desk edges, banister rails and so on). Also consider hiring at your destination.

USING CAR BATTERIES

There is nearly always some kind of light available. For this shot of a Buddhist nun praying at a shrine in Angkor, Cambodia, I needed continuous lighting to help with the dark interior so that the carved stone face outside would not be lost – yet without an obvious on-camera flash appearance. The answer was a regular car battery and a car headlight, wired up with insulating tape and positioned at bottom right. Warning: the sulphuric acid in car batteries is highly caustic and can burn clothing and skin.

Full incandescent lighting

A Rajasthani woman making bread on a hotel terrace in Jaipur. There was time and the facility to set up two portable incandescent lights, each at 800W.

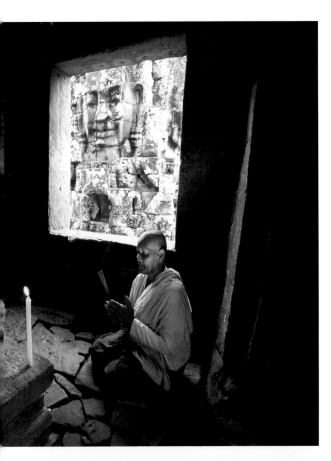

Ambient light
The use of incandescent combined with ambient lighting from outside gives this scene a special atmosphere.

Lowel Tota-light
This is a rugged yet flexible portable lighting system, with built-in barn doors. The doors can be closed completely to protect the tungsten-halogen bulb in transit.

Fill-in incandescent
An adjustable alternative to fill-in flash, an 800W incandescent light covered with a daylight-balancing blue gel was used here to lighten the shadows in this contrasty domestic scene in Thailand.

Protection from cold

THERE'S AN ABSOLUTE PROBLEM with very low temperatures (what they do to the materials of which a camera is constructed, performance of electronics, and to batteries), and a relative problem (temperature changes when moving in and out of heated places). In principle, expose equipment to intense cold for as short a time as possible, but avoid a big temperature contrast. One excellent publication, available online from Kodak, is *Photography Under Arctic Conditions* (Technical Publication C-9) – even though it was written for film cameras, it is helpful and authoritative.

The operating conditions for most digital cameras and media is 0°C to 40°C. Check yours in the specifications given in the manual. Below freezing, there is an increasing risk of failure, and in intense cold (-20°C and below), metal, and some plastics can become more brittle and subject to cracking if knocked hard. Lubricants can thicken, but fortunately there are fewer moving parts in a digital camera than in a traditional film camera. More immediately obvious is that metal will stick to the skin – very painful to remove – so use gloves when handling and exercise caution when holding close to your cheek and nose. In any case, expose the camera to the full cold only when shooting. For the rest of the time keep it well wrapped in a padded waterproof bag and do not allow snow to enter, or else carry it on a strap against your chest underneath a front-zippered parka.

Batteries deliver less power at low temperatures and will need to be replaced more frequently. Cell capacity is very low below –20°C, and a little lower than this the electrolyte will freeze (although when it thaws, it will start functioning again). Allow for this in the number of batteries you carry, and prepare to recharge more frequently than usual. Carry spare

Space blanket
Light and compact, a space blanket in metalized polyester is ideal for wrapping equipment. Also useful for people.

When to take cold seriously
The snow-covered plateau of Tungnahryggsjokull, northern Iceland.

Mitt with fingered liner
One answer to the problem of operating camera controls through thick gloves is to use a mitt containing a sewn-in thin glove. A zip along the side of the forefinger allows you to pull back the outer mitt for shooting.

Silk inner gloves
A more traditional solution is to wear silk inner gloves, which are efficient for short periods when the outer pair is removed.

batteries in a warm place, such as in your trouser pocket.

Temperature changes are inevitable, but keep them to a minimum. The problems are specific to the direction of the change – whether a camera is being moved from cold to warm or from warm to cold. Condensation will form on cold equipment brought into a heated environment, and this can disable the electronics. One solution is to leave the equipment in a cooler part of the building or vehicle rather than bring it into the fully heated area. Another is to seal it in a heavy-duty plastic bag with as much air squeezed out as possible so that condensation forms on the outside of the bag, not on the camera. Even better is to add a desiccating agent such as silica gel.

In the opposite direction, the danger is that snow can melt on the body and in the joints, then refreeze. This can even damage the equipment by expansion. Equally, condensed breath can freeze, so avoid breathing directly onto a warm camera. The solution is to allow time for the equipment in its bag to reach a similar low temperature before using it. One extra aid is to seal joints with tape.

CHEMICAL HAND WARMERS

These are available from outdoor, skiing, and hunting outlets (and of course, online). When activated, the liquid inside the pack crystallizes and in the process undergoes a chemical heating reaction, taking it to around 54°C in a matter of seconds.

Protection from heat and dust

HEAT CAN ALSO CAUSE FAILURE IN THE CAMERA, media, and batteries; remember that the operational conditions are typically 0°C to 40°C. Very high temperatures are less noticeable in dry air as the body feels less discomfort than when conditions are humid, so monitor the equipment particularly carefully in arid, desert locations. Quoted temperatures, as in weather reports, always refer to readings taken in the shade, and direct sunlight falling on electronic equipment can raise the temperature much higher, with the possibility of permanent damage. Do not expose cameras to the sun in already-hot conditions. As with cold weather, it is always best to keep the camera in a bag until you need to shoot. If the camera is uncomfortably hot to hold, its temperature has probably reached about 50°C. High temperatures will reduce the cell capacity and cycle life of Lithium and Lithium-Ion batteries.

The second great problem with dry heat is dust, sand, and grit, more common than in humid conditions and more likely to be airborne. Particles can penetrate joints and will cause abrasive damage to moving parts (even though there are fewer mechanical movements in a digital camera than in a traditional film model), and are very difficult to remove. A special problem for digital cameras is the danger of particles settling on the CCD, which will cause artifacts on every shot. This applies to digital SLRs, in which the CCD is vulnerable whenever you change lenses – only the shutter and mirror protect it, and unlike film, which moves through the gate, it stays in place. Be very careful where you place a camera bag, as it can pick up dust and sand easily, and this can be flicked into the interior. Expose the camera to the air only when shooting. In obviously dusty conditions, such as a duststorm or in a vehicle being driven on an unpaved road, place everything in a large plastic bag, such as a rubbish bag, and tie it up. If, despite precautions, you find that some images have dark spots caused by particles, you can retouch these in an image-editing program.

Taking heat and dust seriously
Sand dunes in Nambung National Park, Western Australia.

CLEANING A CCD

In digital SLRs, the CCD is not sealed and should be checked regularly if you're travelling through dusty, sandy conditions. Do this only in a clean environment. First check the CCD surface by removing the lens, setting the exposure mode to manual and the shutter speed to a time exposure, and pressing the shutter button. The mirror will flip up and the shutter blades open, revealing the CCD. Use a flashlight or a desklight, and angle the camera so that you can see the reflection in the CCD surface. Inspect closely for specks of dust. Clean with a blower or compressed air (the latter gently and from a distance). Do not use a brush or cloth and do not blow on it yourself (for the risk of getting a droplet of spit on the CCD). It is safer to use AC power through the adaptor than to rely on batteries, as a power failure while you are cleaning can damage the shutter.

Reflective foil
As a rule, never leave equipment exposed to direct sunlight in hot conditions, but if for any reason this is unavoidable, cover with something highly reflective, such as foil or a space blanket (see previous pages).

Tape over the cracks
One part of a digital camera that is always susceptible to dust and sand is the memory card compartment. Consider using duct tape or insulating tape to seal this.

Protection from water

Water in all its forms, from condensation to a complete dunking, is particularly damaging to cameras and lenses, and digital cameras are likely to suffer even more than mechanical film cameras because of the amount of electronic circuitry. A few drops of rain are harmless, but the amount of water penetration depends on the build quality of the camera.

The priority is to keep cameras dry, which means at least under cover in wet conditions. If you know in advance that this will be difficult, investigate whether a waterproof housing is available for your particular camera. Some manufacturers, such as Canon, produce these, and they are much less expensive than underwater housings – less bulky, too. This type of case might be valuable in monsoon conditions, or if you are shooting in wetlands or by the seashore. Depending on the design of the camera, it might also be possible to rig up impromptu waterproofing with a clear plastic bag and rubber bands, as shown.

Ziplock plastic bags
Keeps things dry and good for organizing small loose objects.

By the sea, saltwater and salt spray (the latter common in windy weather) bring the added risk of corrosion. Wipe the camera frequently with a clean, dry cloth, and at the end of the day go over all surfaces again, using a damp cloth first. If you drop a camera in water, retrieve it immediately, shake it, open everything that can be opened, wipe off what water you can, then use a hairdryer gently to dry the inaccessible areas. You may still have a problem after this, in which case it will need professional repair.

Condensation is another source of moisture damage, likely in high humidity (the tropics in the rainy season) and when moving from cold to hot (out of strong air conditioning, and from cold weather to a heated interior). See the previous pages for ways of dealing with this.

Flexible case
This sealed plastic container is flexible enough to allow use of the camera, with a special clear lenspiece, but sturdy enough to make it waterproof.

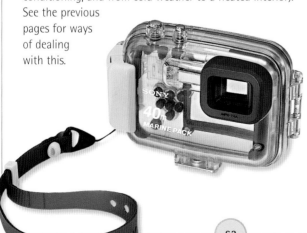

Rigid case
Some manufacturers market rigid waterproof housings which, like this one from Sony, allows the use of a camera and its controls underwater, via special buttons.

INSTANT WATERPROOFING

A clear plastic bag large enough for the camera can be adapted with scissors and rubber bands – provided that the lens protrudes sufficiently from the body to allow the plastic to be secured around it. As long as the lens has a clear view and that there is some play around the controls, everything else can be sealed. Insert the camera into a plastic bag, and secure the bag's opening around the front of the lens with a strong rubber band. Use the LCD screen for viewing; it will be clearer than the viewfinder. An alternative is a large ziplock bag with the opening at the back of the camera and a hole cut for the lens – this has the advantage that you can access the camera from the back easily.

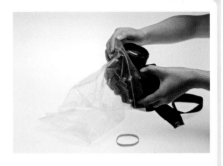

Step one
Insert the camera (with lens attached) into the plastic bag. Be careful not to tear the bag, but do not use a bag any larger than you need.

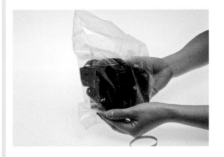

Step two
Rotate the camera around inside the bag until the lens points through the top of the bag (the ziplock hole end, if using).

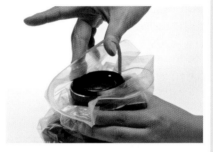

Step three
Gather the bag around the lens and hold it in place with a rubber band. Ensure that the camera is reasonably accessible.

Step four
Using scissors, trim away any excess plastic from around the lens, taking care not to touch the lens with the scissors.

In use
Your camera is now splash-proof, so you'll be able to use it more confidently in the rain. It is not, however, submersible under any circumstances.

Power

Nот ONLY ARE DIGITAL CAMERAS totally dependent on batteries, they consume power at a high level, considerably more than conventional film cameras. Battery management is important, never more so than when travelling and far from reliable sources. There are a number of issues, but all are to do with ensuring you have enough power to shoot from day to day.

Depending on the model, digital cameras have either custom batteries or accept AA size. In the case of the former, you have no choice but to buy that manufacturer's design, and the custom charger. The number of spare batteries that you will need depends on how much you intend to shoot and the frequency with which you can recharge. Usually, on the road, it should be possible to recharge each evening. Check the specifications for battery life but do not take the manufacturer's claims at face value; test it for yourself.

AA-compatible cameras offer much more choice because of different battery types and manufacturers, though on the whole battery life is likely to be less than custom batteries (usually Li-Ion). High-capacity rechargeable batteries are the ideal, but in an emergency you can usually find AA alkalines anywhere to keep you going. There is a wide choice of chargers from independent manufacturers. It is important, however, to check the manual for types of battery that are NOT recommended. (Lithium AAs emit heat and may not be suitable for all makes of camera.)

Wherever there is a convenient power supply, it may be better to use an AC adaptor, usually available separately. It will also save batteries. Whichever AC device you carry with you, charger and/or adaptor, you must be prepared for the plug/outlet types in the countries you will visit. The power tables on the following pages list these.

Camera battery
Some cameras take standard cells, many, however, take specific branded ones like this Canon.

BATTERY RATING

The power capacity of a battery is measured in Milliamp-hours (mAh). This indicates the battery's overall charge storage capacity, and the higher the mAh, the longer the performance. Higher capacity batteries are more expensive, but valuable for digital cameras, which have a high drain. A rating of around 1,800mAh is considered high.

Specific charger
This is the unique Canon charger for the battery shown at the top of the page. It's vital to bring your battery charger, and any spare batteries, on a long trip.

PLUG ADAPTORS

The most convenient solution to different plug/outlet types around the world is an adaptor, and this is essential for a charger or any other device that has a sealed casing. Hot-wiring (attaching bare wires from a local plug with insulating tape to the prongs of the charger or adaptor is not recommended because of the dangers of electrocution).

Label the AC adaptors
If you are carrying more than one device, such as a laptop or stand-alone storage as well as the camera, you are likely to have similar-looking AC adaptors. To avoid confusion, and possible damage to circuitry, label each one clearly.

RECHARGING STRATEGIES

Follow the camera manual, but also bear in mind the following:
- With NiCd and even NiMH (see right), try not to recharge before the battery is fully discharged. With Li-Ion batteries, however, shallow discharge actually increases the cycle life (a cycle is a full charge followed by a full discharge).
- Do not overcharge.
- Smart chargers may be able to do the following: discharge the battery prior to recharging, replenish charging, and switch off once a full charge has been achieved.

BATTERY COMPARISONS

- Alkaline. Widely available, not rechargeable, moderate capacity, keeps charge when not used.
- Nickel-Cadmium (NiCd). The least expensive type of rechargeable battery, gradually loses charge if not used. Suffers from 'memory effect' in that if they are recharged before being fully discharged they 'learn' to have a smaller capacity. Smart chargers can solve this problem.
- Nickel-Metal Hydride (NiMH). More expensive and higher output than NiCd. Also gradually lose power when not used, but do not suffer from 'memory effect'.
- Lithium (Li). Not rechargeable, light, powerful, long life, expensive.
- Lithium-Ion (Li-Ion). Rechargeable, but like Lithium are light and powerful.

Inverter
Relatively expensive, an inverter like the model shown left and far left can be a useful backup when you need AC power. It converts from DC, and fits the near universal cigarette lighter socket in a vehicle. Output on this model is to the standard figure-eight socket.

General charger
If your camera uses a standard cell size, it's possible to get rechargeable batteries too. These rarely last as long as Alkaline cells though, so pack spares.

Power tables

Voltages generally divided between the range 110-120v and 220-240v, with minor variations, although a few countries have both. Cycles are in Hertz (Hz), usually either 50 or 60. There are four major plug-and-socket types, with variations within each, particularly in the European group. Note that some countries have more than one plug type. Chargers and adaptors are dual-voltage, but other pieces of electronic equipment not necessarily.

American

Am

Am

British

Br(M)

Br(G)

Br(D)

European

Eu(J)

Eu(K)

Eu(C)

Eu(L)

Eu(F)

Eu(E)

Australasian

Au

Au

COUNTRY BY COUNTRY

Country	Plug type(s)	Voltage	Hz	Modem adaptor
Afghanistan	Eu(C), Eu(F)	220	50	TPR
Antigua	Am	240	50	TUK, RJ11
Argentina	Eu(C), Au	220	50	TAR, RJ11
Australia	Au	230	50	TAS, RJ11
Austria	Eu(C), Eu(F)	230	50	TAU
Belgium	Eu(E)	230	50	TBG, RJ11
Bhutan	Br(D), Eu(E), Eu(F)	220	50	TFR, RJ11
Bolivia	Am, Eu(C)	110, 220	50	RJ11
Brazil	Am, Eu(C)	110, 127, 220	60	TBZ, TFR, RJ11
Burma (Myanmar)	Br(D), Br(G), Eu(C), Eu(F)	230	50	RJ11
Cambodia	Am, Br(G), Eu(C)	120, 220	50	RJ11
Canada	Am	120	60	RJ11
Chile	Eu(C), Eu(L)	220	50	RJ11
China	Am, Au, Br(G)	220	50	RJ11
Colombia	Am	110-120	60	RJ11
Congo	Br(D), Eu(C)	230	50	TFR
Costa Rica	Am	120	60	RJ11
Cuba	A, Eu(C), Eu(L)	110	60	TPR, RJ11
Denmark	Eu(C), Eu(K)	220	50	TDM, TSC
Egypt	Eu(C)	220	50	TFR, TTK, RJ11
Finland	Eu(C), Eu(F)	230	50	TFN, TSC
France	Eu(E)	230	50	TFR
Germany	Eu(C), Eu(F)	230	50	TGM, RJ11
Ghana	Br(D), Br(G)	230	50	RJ11
Greece	Br(D), Eu(C), Eu(E), Eu(F)	220	50	TGC, RJ11
Guatemala	Am, Au, Br(G)	120	60	RJ11

COUNTRY BY COUNTRY CONTINUED

Haiti	Am	110	60	RJ11
Hong Kong	Br(D), Br(G)	220	50	TUK, RJ11
Hungary	Eu(C), Eu(F)	230	50	RJ11
Iceland	Eu(C), Eu(F)	220	50	TUK
India	Br(D), Br(M), Eu(C)	230	50	TUK
Indonesia	Br(G), Eu(C), Eu(F)	127, 220	50	RJ11
Iran	Eu(C)	230	50	TTK, RJ11
Ireland	Br(G)	230	50	TUK, RJ11
Israel	Own unique standard + Eu(C)	230	50	TUK
Italy	Eu(F), Eu(L)	230	50	TIY
Jamaica	Am	110	50	RJ11
Japan	Am	100	50, 60	TJP, RJ11
Jordan	Am, Br(D), Br(G), Eu(C), Eu(F), Eu(J)	230	50	TJR, RJ11
Kenya	Br(G)	240	50	TUK, RJ11
Korea (South)	Eu(C), Eu(F)	100, 220	50, 60	RJ11
Laos	Eu(thin)	220	50	RJ11
Luxembourg	Eu(C), Eu(F)	220	50	TGM
Malawi	Br(G)	230	50	TDM, TUK, RJ11
Malaysia	Br(G)	240	50	TUK, RJ11
Malta	Br(G)	240	50	TUK
Mexico	Am	127	60	RJ11
Mongolia	Eu(C), Eu(E)	220	50	TPR
Namibia	Br(D), Br(M)	220	50	TSA
Nepal	Br(D), Br(M), Eu(C)	220	50	RJ11
Netherlands	Eu(C), Eu(F)	230	50	TNH
New Zealand	Au	230	50	TUK, RJ11
Nigeria	Br(D), Br(G)	240	50	TUK
Norway	Eu(C), Eu(F)	220	50	TFN, TSC
Pakistan	Br(D), Eu(C)	230	50	RJ11
Panama	Am	120	60	RJ11
Peru	Am, Eu(C)	220	60	RJ11
Philippines	Am, Eu(C)	115, 220	60	RJ11
Poland	Eu(C), Eu(E)	220	50	TPR
Portugal	Eu(C), Eu(F)	220	50	TDM, RJ11
Romania	Eu(C), Eu(F)	230	50	RJ11
Russian Federation	Eu(C), Eu(F)	220	50	TPR
Saudi Arabia	Am, Br(G), Eu(F)	127/220	60	TAE, TFR, TUK
Senegal	Br(D), Eu(C), Eu(E), Eu(K)	230	50	TFR, TSA
Seychelles	Br(G)	240	50	RJ11
Singapore	Br(M), Br(G), Eu(C)	230	50	TUK, RJ11
South Africa	Br(G)	230	50	TSA
Spain	Eu(C), Eu(F)	230	50	RJ11
Sri Lanka	Br(D), Br(M)	230	50	TUK, RJ11
Sudan	Br(D), Eu(C)	230	50	TIY
Swaziland	Br(M)	230	50	TUK
Sweden	Eu(C), Eu(F)	220	50	TSC, TSD, RJ11
Switzerland	Eu(J)	230	50	TSZ
Taiwan	Am	110	60	RJ11
Tanzania	Br(D), Br(G)	230	50	TUK
Thailand	Am, Eu(C)	220	50	RJ11
Turkey	Eu(C), Eu(F)	230	50	TTK, RJ11
Uganda	Br(G)	240	50	RJ11
United Arab Emirates	Br(D), Br(G), Eu(C)	220	50	TAE, RJ11
United Kingdom	Br(G)	240	50	TUK
United States	Am	120	60	RJ11
Venezuela	Am	120	60	RJ11
Vietnam	Am, Br(G)	120, 220	50	RJ11

Image storage

Dᴵɢɪᴛᴀʟ ᴘʜᴏᴛᴏɢʀᴀᴘʜʏ has dynamically altered the logistics of shooting, and at no time is this more obvious and important than when travelling. No longer do you have to estimate the quantity of film you will need, or plan to replenish stock at dealers along the way. But you do have to plan for storing the images in digital media; more than that, you need to have a sensibly worked out 'production flow' of image transfers that will keep pace with the way you shoot on a trip.

The numbers are easy to calculate, and start with the file size of one of your typical images. This depends not only on your camera's resolution but also on what use you want to make of it – in other words, which of the choices of image quality you go for. Most professionals will use the maximum. Memory cards of whatever capacity are only temporary storage, and you will need to transfer the images from them at regular intervals. For example, a 128MB memory card will take about 100 images shot at normal compression on a 5-megapixel camera, but only about 15 in RAW format (the highest quality). Card-sized hard drives such as IBM's Microdrive alter the equation somewhat, as a 1GB drive can store eight times this amount. Still, that is only about 100 top-quality images, which might not get you through the day. Moreover, the high price of miniature hard drives makes cost-effectiveness a part of the calculation.

Nikon Coolwalker
One of many devices now appearing which includes a large hard disk, allowing you to copy images from a memory card, store them, and view them on screen.

KEEPING CDS SAFE

A padded case for carrying a number of CDs – say 10 or 20 – is a useful space saver, and can be bought at most music stores.

Card reader
A card reader will plug into your computer and allow you to transfer image files directly from the memory card, without the need for connecting the camera.

The most efficient strategy for long-term shooting (highly relevant to travelling) is to have sufficient memory cards/miniature hard drives to continue shooting until you can discharge them onto a larger hard drive. The quantities depend on your way of shooting and on the kind of subjects that you expect to come across on a trip – parades and special events, for instance, tend to consume images faster.

This shines the spotlight clearly on portable long-term storage, and some interesting products have been developed to meet the new demand. The most immediately obvious answer, though not necessarily the best, is to carry a laptop and download images onto its hard drive. This is perfectly sound, as long as you don't mind taking a computer on the trip. Some laptops are indeed very small and light, but they still need the same care and attention as all computers.

A device that is made specifically for travelling digital photographers is the stand-alone portable storage unit that features a small, typically 6.3cm (2½in), hard drive and a port that accepts memory cards directly. There are several models available, with capacities up to 30GB, that can be AC- or battery-powered. These PDA-sized devices, which weigh next to nothing, are convenient enough to consider carrying in a shoulder bag as you shoot. All of this bypasses the computer completely. This is an improving technology, so monitor the latest developments: the second generation of portable storage devices also features a viewing screen that allows you to see the images themselves.

In digitally developed countries, like Japan, many film-processing labs and camera dealers offer inexpensive copying from memory cards onto CD-ROMs. If you check in advance that this service is available at your destination, it saves time and effort and removes the need to carry your own storage media. Even in less sophisticated places, if you have a card reader you could look for an Internet café or computer centre, or even the business centre of a hotel, that would be willing to download your images and then burn them onto a CD-ROM.

Laptop card reader
Like the external card reader shown opposite, this is simply an adaptor for laptop computers allowing you to copy files from a memory card as if it were a disk.

Memory cards
Similar technology, but different shapes. Clockwise: Memory Stick, MMC, Secure Digital, Compact Flash (by far the most common), and Smart Media.

A new shooting culture

THE LARGEST POTENTIAL CHANGE being worked on photography by digital cameras is the way in which we shoot, and this is a response to how images are now stored. It is a surprisingly deep change, though not fully realized by many camera owners, because it affects the very idea of permanence and value of images. It's probably no exaggeration to say that we all have an innate respect for the physical presence of an original picture. Something solid carries the image, whether canvas for a painting or a negative for a photograph, and somehow this makes it unique and, to an extent, precious.

Not so digital photography. Each image has only a notional presence, and this is changing the way photographers shoot. With film there was a reluctance (normally) both to overshoot and to throw away surplus frames at the end of a shoot. This was partly to do with cost, but partly also to do with the inherent value of each original frame. The dynamics of digital photography are quite different, and appreciating this can improve your results. The capital costs may be higher (memory cards, microdrives), but the running costs are extremely low. The only limit to the number of images shot is the short-term storage capacity, and as we saw on the previous pages, the solutions for that are improving all the time.

This is creating a new shooting culture of 'overshoot, edit back' that will change the way most photographers work. It goes like this. Instead of holding back and waiting for the right moment to shoot, you can now fire away in the knowledge that later you can edit the sequence, selecting the best frames and discarding the rest. In a situation that formerly called for pause, hesitation, and the exercise of judgement in when exactly to shoot, the procedure is changing. Essentially, it means transferring discrimination to the editing stage, withholding final judgement until later.

Does this sound good or awful? Perhaps inevitably, it is already creating a rift among photographers, some of whom deplore the

Editing: step one

The first procedure is the download from the camera or memory card, with all the images shot displayed in the browser. Deleting images permanently at this stage is tempting but dangerous. It is better to confine any deletions to images that are technically obviously faulty, such as out of focus or with camera shake, and then only after close inspection of the full-sized image. Make a first selection of what seem to be the best images in a set by tagging them (the exact procedure varies according to the software).

idea of taking less care through the viewfinder. The dangers are obvious: indiscriminate hosing of a subject can only lead to poorer photography, and editing needs good material to work with. Handled sensibly, however, this method can be used to raise your score of successful images. There are, for instance, many occasions when it isn't possible to be certain that you have the best picture – there may be a better one to come. In such 'improving situations', in which the light may be shifting, or the composition changing, or you are hoping for a certain expression or gesture, the accepted solution is to shoot as soon as you have an acceptable image, then try to improve on it. In this scenario, a digital camera is perfect, because it removes the restriction of the amount of film to use and waste.

As in other areas of digital photography, this involves thinking forward as you shoot, seeing the image in its place among the final selects at the end of the trip. In fact, I know photographers who have taken this approach with film for years, shooting heavily whenever they felt that they have a winning situation in front of them – at least, as long as the client is paying for the film. One of the proverbs of professional photography was 'the cheapest thing is the film', meaning that after all the time, effort, and expense of getting yourself to a promising picture situation maybe halfway around the world, don't be miserly with it. Digital photography makes the advice redundant. Marshall McLuhan, the original media prophet, wrote in his famously enigmatic way 'the medium is the message'. It is also the method.

Editing: step two
The 'first selects', once tagged, can be searched for and displayed in their own browser window. This is a temporary display, so the images remain in the same folder as all the others.

Editing: step three
After examining each of the first selects full-size on the computer screen, the preferred one is optimized and saved with a different filename in a different folder.

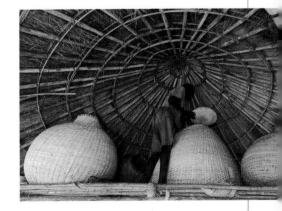

Editing options

EDITING A LARGE TAKE OF PHOTOGRAPHS has always been an integral part of the creative process. With film it was usually reserved for the return home, with all the rolls developed and examined together, but now, digitally, it can be integrated even more tightly into the shooting. Images are available for viewing immediately, so that at the end of a day you can valuably review what you did.

This, in much the same way as dailies are used in the motion picture industry, brings an entirely new idea to digital travel photography – feedback. Given an adequate viewing system, you can sit at the end of a day in a hotel room, and examine the take. By doing this you have an overview of the trip as it progresses, as well as valuable feedback on successes. It does, however, need a computer. If you travel with a laptop, good. Otherwise, on-the-road editing is one more factor to consider.

PORTABLE PRINTER

A valuable, unique tool for shooting in situations where goodwill is paramount, a portable digital printer makes it possible, at relatively low running costs, to supply the people around you with instant mementoes. In this sense, the portable printer can take the place of Polaroid prints. The only major drawback, as for Polaroids, is that once seen, everyone wants a print! This Canon CD-100 uses dye-sublimation, thermal transfer technology to produce 300 dpi 10 x 15cm digital photo prints with a protective coating. It can be powered by a rechargeable battery and with a car adaptor kit.

Workflow software
Another possibility for viewing images is software that concentrates on photographic workflow, combining all the functions, including image-editing. The one shown here is PhaseOne C1 Pro, aimed at pro photographers.

File browser
This is Photoshop's File Browser. It displays thumbnails of any folder of image files, and any relevant information you choose, like size or resolution.

You can perform an immediate edit with the camera as long as the images are still on the memory card, but on a long trip you will have to download these – onto the hard drive of a laptop or a portable storage device. Some portable storage models allow viewing on a small screen, which is useful, but not particularly convenient for editing, which really needs images to be viewed side by side in groups.

The software for editing digital images is classified according to the sophistication of its features. Browsers are generally restricted to doing just that – viewing the stored images in an on-screen window on the computer. All the camera manufacturers supply a browser to display images downloaded from the camera.

A step up from browsers are image management programs. These are able to display almost any known format of image, not just those created by the camera, and include ways of ordering the images and the means to search and find images. As your collection increases, an image database becomes essential.

Portable computer
Travelling with a laptop computer gives you all this storage space and functionality on the move.

Database
At a higher level of functionality is an image database, which features more search/cataloguing capabilities. This one is Extensis Portfolio 7.

Sending images

Digital photography brings immediacy, and with it the opportunity to send images electronically to clients and friends. Transmitting photographs while you are still travelling opens up new possibilities: for professionals the ability to deliver an assignment quickly and to submit images to a stock agent, and for anyone to send digital postcards, to update a personal website, and even to archive images for safe-keeping on a remote server.

The standard image compression system used in digital cameras is JPEG, which is at the same time an image file format. This was originally developed for electronic transmission, so is ideal for sending by email. JPEG images need no further encoding before sending, and can be read by any of the operating systems – Windows, Macintosh, Unix, Linux. All you need to ensure is that you have email access in the destinations to which you are travelling. Note that as laptop and PC ownership increases, Internet cafés tend to decline. This has already happened in Japan, where there are very few because most people have their own access.

A professional alternative favoured by hard-news photographers is 'cellphone to modem', in which a mobile handset is connected to a laptop, and images are sent using software such as Hyper Terminal, Timbuktu Pro (both for PCs), Z-term, Microphone, or Global Transfer (the last three for Macs). Picture desks at newspapers and some magazines have a number dedicated to this. Transfer speeds can be slow, unless the mobile phone is capable of High Speed Data and is used on a high-speed network. A sat-phone naturally extends your range, but calls are expensive. The alternative is a card that fits in the PCMCIA slot of a laptop – essentially a mobile phone without the handset shell.

Even more convenient, but dependent on finding a server location when you need it, is Wi-Fi, which stands for wireless fidelity and is a standard for wireless local area networks also known as IEEE 802.11. For this, you need a laptop with a wireless adaptor installed.

NAMING NAMES

File name protocol is essential. The standard points to follow are:
- The only punctuation in a file name should be a dash (-), underscore (_), or dot (.).
- When sending a JPEG file, add the file extension .jpg.
- Use lower case throughout.
- In a sequence of similar images, use a number sequence to differentiate, e.g. grandcanyon-01.jpg, grandcanyon-02.jpg.

WEB-BASED E-MAIL

When travelling abroad, the most reliably accessible email services are web-based, meaning that the service operates through a website and so can be accessed from any computer anywhere. If your normal email account at home is that offered by your ISP (Internet Service Provider), there may be problems accessing it cheaply from foreign countries. The most popular web-based email includes MSN Hotmail and Yahoo!, and these offer a free basic service. Of course, nothing is really free, and in this case the advertising pays. Drawbacks are limits to the amount of data that you can store, often slow speeds and 'traffic' jams, and spamming. Nevertheless, as a second email address they can be very valuable.

FTP

File Transfer Protocol (FTP), a standard Internet protocol, is the simplest way to exchange files between computers on the Internet (in information technology, a protocol is the set of rules used in a telecommunication). It uses the Internet's TCP/IP protocols. (Transmission Control Protocol/Internet Protocol). It is widely used, particularly for software and large files, and for images. Most people's experience with FTP is to download files from websites, but it has a special value for photographers in enabling them to send images to another computer, where they can be archived safely. Many photo agencies now use FTP for photographers to send digital images to their server. Although you can use FTP with your web browser, there are also specialized programs for transferring files and decompressing them, such as CuteFTP and WS-FTP for Windows, and Fetch for Macintosh. And some photo agencies use their own programs from a website that their photographers can access easily. Typically, to upload an image you would already have been given the host address, your own user ID, and a password for security. Using a program like Fetch, you dial up the host server, enter your ID and password, and then drag and drop image files onto a window. The program does the rest. If you are carrying a laptop with you on your travels, you simply need to have the software installed, and be able to establish an Internet connection.

SATELLITE

With most digital mobile phone networks, such as those in the US and most of Europe, it's possible to transfer data using FTP by connecting your phone to your computer. It is also possible to do this using the global satellite networks that cover areas it is simply impossible to reach using cellular masts. Inmarsat, for example, covers the whole surface of the Earth except the poles, and can transfer data at up to 144Kbps, though 9.6Kbps is standard on the other three networks.

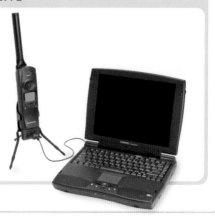

Visa requirements

Most countries have visa requirements, although these may be waived for nationals of certain other countries. In addition, some countries will offer visa on arrival (VOA), meaning at the point of entry, while others demand that you have a visa in advance, already issued in your own country. Even with VOA, there are different levels of bureaucracy. At its simplest, the visa will simply be stamped into your passport by the immigration official, but another method is that you first hand a visa application form at one counter, pay, and then proceed to immigration.

A complete listing of visa-issuing details is too complex to give here, as it depends on the country of which you are a national as well as the country you are planning to enter. Check well in advance at home with the consular sections of the countries to be visited, paying particular attention to the time needed to issue the visa. Many embassies and consulates now offer visa application forms by fax-back and as downloads from a website, and it is worth doing an Internet search for the consular website – this will save you time and money. For visas in advance, if the issuing is likely to be difficult or inconvenient, consider paying a travel agent or visa service to do this for you (but this may be costly). You will normally need the following, either for a visa in advance or on arrival:

- At least six months from the date of leaving the country before your passport expires.
- Enough blank pages in the passport for the entire trip. Some visas take up an entire page.
- Several passport-sized portraits of your unsmiling self (3.5 x 4.5cm/1⅓ x 1¾in will usually do). Prepare these at home with your digital camera, using an image-editing program to gang up a number of the best onto one sheet for printing.

Depending on the kind of trip you are planning, you might want to check the country's regulations for visa extensions (in

Passport expiry
Make sure that your passport is completely up to date. Allow a full six months from the date of leaving the country before your passport expires.

Passport control
You won't be able to avoid passport control on your travels. Always be prepared to have the right documentation with you at all times.

case you change your mind and want to stay longer) and multiple-entry visas (for backtracking). The most common categories of visa are Tourist, Business, Transit, Resident, and Student. The one to ask for is Tourist, unless you have a very good reason for a business or other visa – and supporting documentation. In some countries there are also internal restrictions not covered by the visa. Thus in India, for example, to visit such border areas as the northeast you would need an Inner Line permit, which is not readily given. The consul or embassy will be able to tell you about these.

Needless to say (I hope), photographers, journalists, and other members of the media tribe are unwelcome in many more places than they are tolerated. Whatever good it does for the ego to put 'photographer' as a job description on a visa application, it will not help your entry. Indeed, it will get you barred from many countries, and that information is likely to stay in the immigration department's database.

Also related to entry regulations are the matters of health. You may be asked to sign a declaration saying that you do not have certain diseases, or have not been on a farm or ranch recently, or have not visited certain countries currently infected with yellow fever or something equally serious, and occasionally you may be required to show a vaccination certificate. If nothing else, this should be a prompt before you go to have the necessary vaccinations. Your doctor can advise you which to have, depending on your destination and the time, but at least run your eye over the following checklist:

- Cholera
- Diphtheria
- Hepatitis A
- Hepatitis B
- Meningitis
- Paratyphoid
- Polio
- Rabies
- Tetanus
- Tuberculosis
- Typhoid

Negotiating customs

THERE ARE TWO DIFFERENT considerations here: negotiating your own country's and everywhere else. If you are returning from abroad with more than the usual tourist's photographic equipment, you may be targeted in case you have bought a camera abroad and failed to declare it. This is one more reason for not travelling with obvious photographic cases. A sensible precaution is to carry photocopies of your equipment receipts as evidence that duty has been paid on them (see Documentation page 82), and even a dated list of the equipment prepared before your leave – it proves nothing, but establishes that you are organized. Rates of duty vary from country to country, but if you do plan to buy equipment in, say, Tokyo, you should check before leaving home what the rate is – it may nullify the apparent price advantage.

Dealing with foreign customs is another matter, and likely to be a problem only if you have professional-looking equipment. Pragmatically, there are three kinds of customs:
- Reasonable and law-abiding.
- Strict and law-abiding.
- Apparently strict but corrupt.

And of course this last group is the most difficult. Although rare, it does happen that you may be given a bit of a hard time over photographic equipment, and the motive may, perhaps obviously, be money. Always exercise extreme caution when attempting to bribe a customs official, even in the most blatantly corrupt countries. It puts you at risk of being accused of breaking the law, and so in even more trouble. If you are being met by a travel representative (and you might in any case consider this in 'difficult' countries), ask to contact them and let them deal with the matter (the official will also be happier dealing in his/her own language with a national than with you as a foreigner).

Digressing on corruption in general, not just at customs, the basic rule is to know exactly how it is done in that particular place, wherever it is – and the exact going rate. Techniques that work in one country do not necessarily in another, and this is one good argument for not inserting banknotes in your passport. If you don't know how to do it, don't try.

Baggage reclaim
You won't always be this well directed as you make your way through arrivals, baggage reclaim, and customs.

NAVIGATING 'DIFFICULT' CUSTOMS WITH CAMERAS

- Do not show receipts that indicate the true value.
- Do not carry expensive equipment in original cases. This applies particularly to big lenses.
- In a corrupt country the purpose of customs harassment may be to extract money from you. Making a loud public scene is unlikely to help. Try being firm and polite, insisting that the equipment is for your personal use as a tourist to record this beautiful country.
- If this fails, try to negotiate the 'import duty' down.
- In the corrupt scenario, any money you hand over is a bribe. Forget 'returnable deposit'. Ask for a receipt only for your own amusement.

CARNETS

The ATA carnet is an international customs document that allows goods to enter foreign countries for up to one year, and although it is nearly always easier for a photographer to carry cameras as personal goods, there are occasions when it is worth the extra effort (which is considerable) to have this customs waiver, that is essentially what a carnet is. For instance, if you were doing a fashion shoot which called for cases of clothes to be taken abroad, a carnet might be the answer. The system, which allows temporary duty-free imports, was created by the World Customs Organization (WCO) and is managed by ICC's World Chambers Federation (WCF). Today, around 60 countries accept the ATA carnet. Under the system (ATA is an acronym for 'Admission Temporaire/Temporary Admission'), once you have a carnet you do not need to make a customs declaration and no duty is charged on the merchandise, provided that it is re-exported. The countries involved in the scheme accept the carnet as a guarantee that customs duties and other taxes will be paid if the goods listed in the carnet are not re-exported as stipulated within the time limit. The guarantee is made by one organization in each country, usually a chamber of commerce. In the United States, for example, the guaranteeing association is the US Council for International Business (USCIB), in France the Paris Chamber of Commerce and Industry, and in the United Kingdom the London Chamber of Commerce. The advantage is that you make customs arrangements in advance and use a single carnet to pass with a minimum of hassle through each country's customs. The carnet allows an indefinite number of trips during the 12 months that it is valid. The disadvantage is cost: between about £65 and £110 for the carnet and a returnable deposit of 40% of the value of the goods or equipment. For more information, including an up-to-date list of countries, see http://www.atacarnet.com/.

COUNTRIES WHERE THE CARNET IS ACCEPTED

- Algeria • Estonia • Italy • Mongolia • Slovenia • Andorra • Finland • Ivory Coast • Morocco
- South Africa • Australia • France • Japan • Netherlands • Spain • Austria • Germany • Korea
- New Zealand • Sri Lanka • Belgium • Gibraltar • Latvia • Norway • Sweden • Bulgaria • Greece
- Lebanon • Poland • Switzerland • Canada • Hong Kong • Lithuania • Portugal • Taiwan
- China • Hungary • Luxembourg • Romania • Thailand • Croatia • Iceland • Macedonia • Russia
- Tunisia • Cyprus • India • Malaysia • Senegal • Turkey • Czech Republic • Ireland • Malta
- Singapore • United Kingdom • Denmark • Israel • Mauritius • Slovakia • United States • Belarus

Travel security

Digital cameras and the other electronic equipment that accretes around them, such as laptops and image banks, are highly desirable. Because of the constant updates and new models, they are arguably even more desirable than film cameras used to be. From a thief's point of view you are a walking gift shop, the more so if you are travelling in parts of the world with poorer economies than your own. Add to this the inherent value of photographic and computer equipment, and it clearly makes sense to take real precautions, even if you have the equipment fully insured for the trip (as you should). According to common sense:

- Never leave your equipment unattended anywhere.
- Do not advertise the equipment with camera manufacturer's labels and expensive new cases, however good they may make you feel. Old and worn attracts less attention.
- Do not leave your camera on the seat of a car with the window down, particularly in a city. It's perfect for snatching at a traffic light.
- If you carry a lot of equipment when flying, some will have to go in the checked baggage, but make sure that the essentials are with you as hand baggage – enough to be able to continue shooting if the checked baggage goes astray.
- If you are sitting in a well-populated place such as a restaurant or hotel lobby, never leave a shoulder bag sitting untethered or simply hanging on a chair back. Anchor it somehow, such as by slipping the strap under a chair leg.

Lock and strop
Consider not only a selection of padlocks, but a strop (any line or cable fitted with hard eyes at either end). This can be wrapped around and through things to secure a variety of cases and equipment. Semiflexible stainless twisted cable like this is available made to measure from any yacht chandler.

SECURE THE STRAP

Shoulder bags have straps – use them for security whenever you put the bag down. One simple technique is to place one leg of your chair over the strap, another is to use a clip of some kind – here a karabiner.

LOCAL TECHNIQUES

With the exception of Japan, which still has almost nonexistent street crime, most places have a community of petty criminals on the lookout for cameras and other valuables, and they develop special methods. Pillion passenger on a motorbike is one favourite, sometimes further refined into a smash-and-grab, targeting the rear windows of cars stopped in traffic.

WARNING

Complacency gets you in the end. I spent 25 years travelling frequently, and to some dubious places, without having a single camera stolen – until I made the unforgivable error of locking my equipment in the trunk of a rental car one night. Never mind that it was hidden from view and that the car was securely parked in a five-star resort hotel in Scotland. I'd been seen shooting the day before, and was targeted. I learned my embarrassing lesson.

Travel advisories

Government agencies usually have websites on which are posted up-to-date travel advisories covering different countries and their potential hazards.

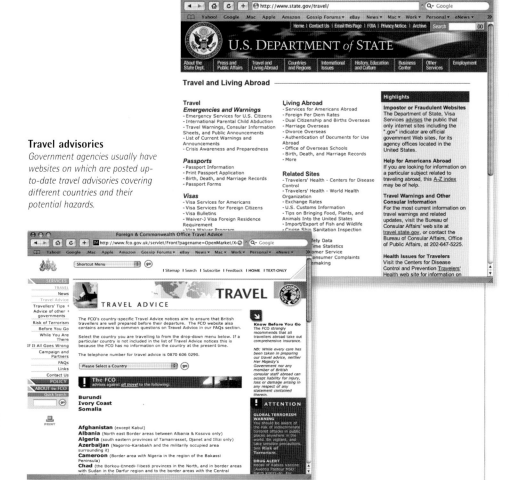

Documentation

THE ABSOLUTE PREREQUISITE FOR TRAVEL is having the relevant documents all in order. Check everything, read everything, from the dates and times of flights (mistakes are always possible, particularly with flights departing around midnight) to the time left before the passport expires (should not be less than six months from your last date in another country). Not all of those shown here will be relevant. For double safety, photocopy all of the key documents or pages – twice, and take one set with you, separate from the original, and leave another set at home where, in an emergency, someone you know can find it.

Passing through
Always ensure you have the correct documentation with you when you travel. Obviously your passport is your top priority.

INSURANCE

Special policies are available for photographic equipment, and some insurers specialize in this area. You can save on the premium by dividing the equipment lists into two – the things that will stay on your home or office premises, such as a desktop computer, and the equipment for travelling. There may be additional savings by including some equipment on existing policies that you may have. There is no point having anything insured twice. Review your policies, including any that you may have acquired free of charge through a credit card or a package holiday, and see how much of your photographic equipment they may cover.

- Compare the cost of individual trip-by-trip insurance and an annual policy that covers an overall amount of travel.
- Make a list of all items (the 'schedule') together with serial numbers (if any) and the replacement value of items over a substantial amount – say £50.
- Find the replacement value from a dealer's online catalogue. Be realistic, remembering that if you undervalue to save on the premium that is all you will get, but if you overvalue you will increase your premium.
- Pay attention to exclusion clauses, such as travel to dangerous locations and leaving equipment in vehicles. In fact, be careful to read the policy thoroughly before you leave on a trip. Most of the exclusions are common sense.

Checklist

☐ Tickets

☐ Passport

☐ Second passport (some countries)

☐ Visa

☐ Permits

☐ Equipment list

☐ Equipment receipts

☐ Photo ID

☐ Press card

☐ Student card

☐ International driver's licence (national driver's licence)

☐ Vaccination record (e.g. International Certificate of Vaccination, International Health Card)

☐ Equipment instructions

☐ Essential addresses, telephone numbers, email addresses

☐ Medical insurance documentation

ON THE ROAD

Once the trip is under way, the rules and the skillsets change. Adaptation, response, and improvization combine to make up the new order. Unfortunately, all too typically these are first brought into play because of something left behind. Experienced travellers know better than to expect total efficiency in their own preparation, and instead allow for a logistical gap in the packing list.

Although leaving something behind at home as fundamental as a battery charger may well seem disastrous on the day of arrival at your destination, in practice few things are irreplaceable. Enter the world of the workaround. There is a cut-off point to preparation, before which everything is possible but after which travel has to be dealt with on an ad hoc basis, and preferably in that frame of mind. Here we deal with the day-to-day practicalities, from hiring vehicles to coping with restrictions on shooting. Being on the road is a kind of liberation, as in the book of the same title by Jack Kerouac, and it calls for a shift in emphasis from careful planning to on-the-spot reaction. Which ultimately means encountering and enjoying the unexpected.

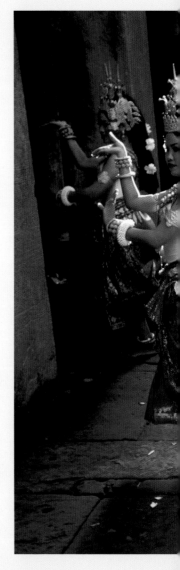

Travel photography and spontaneity

Travel photography is concerned with how things actually are, with a strong dose of documentary, and the idea of an out-and-out setup is anathema. But quite often events are openly staged for people's enjoyment, and the photographer's usual problem is finding a vantage point for effective shots when there is an audience that also wants a good view of what is happening. In this case, the performance was a traditional Khmer dance staged in the ruins of a twelfth-century temple at Angkor, Cambodia.

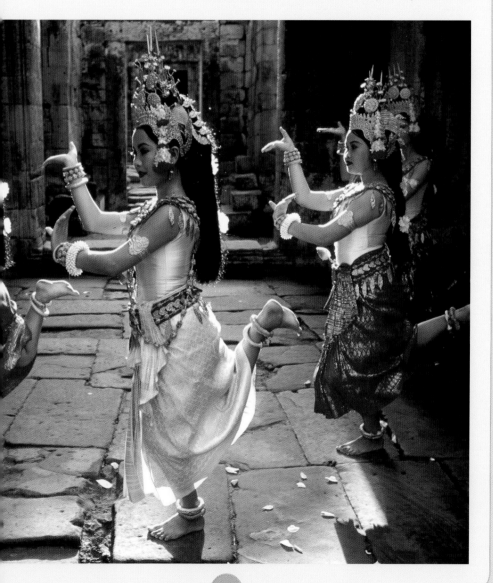

Forecasting weather

WEATHER IS THE IMMEDIATE, day-to-day expression of climate. Assuming you have been able to choose the right season for shooting in your destination, you will still usually need to check the weather. How important this is depends on the kind of climate you are in – in some, such as Mediterranean or Savannah, certain times of the year may be completely reliable, day after day. In others, such as the Marine climate of Western Europe, much less so. In addition, the reliability of weather reports varies – Western Europe is particularly difficult for prediction because of the string of complex weather systems approaching it from the Atlantic.

The sources for weather information are:

- Online. There are both International and national weather websites, and these include the following:
 - **Weather Channel**
 http://www.weather.com/
 - **Weather Underground**
 http://www.wunderground.com/
 - **National Weather Service [US]**
 http://www.nws.noaa.gov/
 - **Accu Weather**
 http://www.accuweather.com/
- Local radio and television stations.
- Telephone weather services, some of them specific to mobile phone networks.

For photography, the most important weather information is usually the forecast for sunshine, clouds, and rain. All three are related, as clouds are condensed water vapour in moist air. Most of the world's rainfall is frontal, when two different air

Weather report
Weather.com offers indispensable advice on everything you need to know to bring you up to date with the weather conditions for your destination.

CLOUDS AS LIGHT VS. SUBJECT

Cloud cover impacts on photography in its effect on lighting – it blocks the sun to varying degrees according to how dense the clouds are. But it can also feature in images as a key element. Distinctly shaped clouds tend to make the most interesting picture elements, and these include fair-weather cumulus, high wispy cirrus, and the anvil-shaped cumulo-nimbus of convectional thunderstorms. Clouds also respond to sunlight in endless ways.

masses meet. Air moves from high pressure to low pressure, so that in a low-pressure system air is drawn inward, spiralling gently, and because it comes from different directions there are usually masses of warm and cold air. The line where they meet is called a front, and the warm air tends to rise above the cold, making rain likely. Western Europe and the northwest United States receive most of their weather this way, with a succession of fronts moving eastwards. This accounts for the sequence of clouds, rain, and clear skies, and the timing is difficult to predict.

There are two other common kinds of rainfall. One is convectional, and occurs in many parts of the tropics and on hot days in landlocked plains. As the ground heats up during the day, the lower air also heats, and rises rapidly. As it rises, it cools, and loses its ability to hold water vapour, and the result can be vertical stormclouds several miles high, with dramatic anvil-shaped thunderheads and violent rain accompanied by thunder and lightning. The other is orographic, and this occurs when moving air meets mountains and hills. They force the airflow to rise, and if it is already moist, it cools and can no longer hold the water vapour, which condenses quickly.

Recognize the signs

It helps to become familiar with local sky patterns and conditions – and to understand what they mean. This advancing line of clouds at a low altitude over Scotland clearly suggests a demarcation between types of air – and is part of a cold front, making showers likely.

Dramatic weather

Because of the impossibility of predicting strikes, the best thing is to leave the shutter open until a lightning strike occurs. This means shooting when it is fairly dark to avoid overexposing the scene.

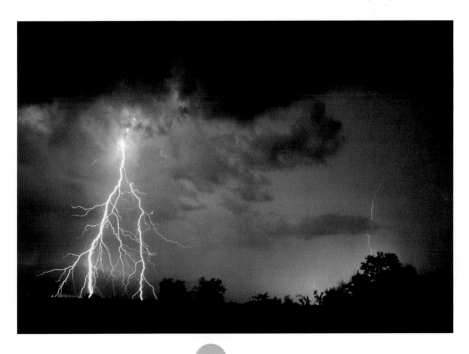

Variety of coverage

TRAVEL PHOTOGRAPHY is inevitably about a sense of place, and this has many different expressions. In any one location you can expect to find all kinds of views, incidents, and imagery – provided that you make a conscious effort to vary the way you shoot. Think of the collection of images that accumulates over a day's shooting as a set to be viewed together. They will acquire more combined impact if they have variety in appearance.

THE VALUE OF FOCAL LENGTH

Shooting with a variety of focal lengths brings diversity to the shoot, not so much because they allow you to cover more or less of a scene from one viewpoint than because they have their own graphic identities. Wide-angle lenses (and the wide end of a zoom range) naturally cover more of a scene than usual, but they have other, subtle qualities. By compressing a wide angle of view onto the same size of film frame, they create a strong perspective that can give photographs a distinctive flavour. They also tend to draw the viewer into the picture for a more subjective impression. Lines and shapes are stretched toward the edges – and even more toward the corners – giving an exaggerated perspective. Diagonals become a strong part of wide-angle views, often converging towards the distance. You can use these to put energy into a photograph, but beware of distortion that simply looks odd – as a rule, avoid placing obvious shapes like circles or faces near the corners. With telephotos, too, there is more to the kind of image than just the coverage. Long focal lengths give a compressed perspective, which can make interesting compositions in which the planes of a scene are 'stacked' one behind the other, and makes distant objects seem much larger. Telephotos are good for isolating and emphasizing a single subject. Their depth of field is very shallow, which helps subjects stand out against soft backgrounds.

CHECKLIST

- Frame vertical as well as horizontal where appropriate.
- Try a range of scales.
- Keep on the lookout for close-ups.
- Where possible include a wide, establishing view – even a panorama.
- Vary focal length for character as well as convenience.
- Look for graphic, even abstract compositions as well as the more predictable views.

People as accent
Two women against the Petronas Towers, Kuala Lumpur. Shooting with a wide-angle lens makes the most of a strong contrast between people and environment.

Detail
The carved wooden door of an Italian church. Closing in on details extends the range of experience.

Abstraction
Fog over San Francisco's Golden Gate Bridge gave an opportunity, by using a long lens (400mm efl) to create an abstract pattern from a detail of the structure.

Isolating colour
The attraction here was less the work going on than the classic colour combination of orange and blue. Closing in on the scene to avoid the surroundings made the most of this.

Themes

Visual variety, as explained on the previous pages, has the effect of making the entire take broader and more interesting. At the same time, a travel shoot can nearly always benefit from continuity – a theme running through it. There's no contradiction here: the variety operates within the take, whereas continuity of style or subject is what helps to distinguish your shooting and that particular trip from all the others.

Many photographers naturally develop an identifiable style – some more definite than others – and this tends to give continuity. Style, however, is not easy to play with

Temple town

These four images were all taken in a small provincial town in northern Thailand, Lamphun. Certain colours and decorative themes run through them. The cultural pride of the town is its ancient principal temple, at the heart of which is a magnificent gilded stupa.

Market life

As in many such towns, the morning market is the centre of activity each day – always a good opportunity for photographing people interacting and going about their normal routines.

and manipulate. Deliberate attempts to change it or add to it can often end up looking mannered or gimmicky. A more plausible way of bringing continuity to the photographic record of a trip is to focus on one or more themes. Typically, these revolve around subject matter.

A particular destination may suggest its own storyline very easily, such as a Thai country town, as in the examples here – immediately striking are the distinctive Buddhist temples, monks, cycle rickshaws, and graphics. Of course, these are the things that catch a Westerner's eye – for a Thai they are normal and less immediately interesting. Another theme might be the journey itself – or one aspect of it. On an Aegean cruise on a newly built four-masted clipper ship, the work of the crew had a special interest. Large sailing ships are not so common, and the skills for dealing with the sails and rigging are now rare.

Monks
Traditionally all young Thai men should enter a monastery for at least a few weeks or months, and in the provinces many still do.

Cycle rickshaw
Gradually disappearing but still a feature of small-town life is the cycle rickshaw.

More themes

OTHER THEMES may suggest themselves as you travel around a region, simply by catching your eye. The Indian street graphics shown here are just such an example – not important enough to deserve an entry in a guidebook, but an immediate attraction when driving around, at least to me. But perhaps the most fruitful way of finding a theme is to follow your personal interests and whims. These could be in art, architecture, transportation, food, children's toys and games, anything.

I have a friend who is crazy about photographing reptiles, and over the years this has given him a very purposeful itinerary, as well as an outstanding collection of images. A more

Indian graphics
Two of the characteristics of popular graphics in India are the vibrant use of colour and painting by hand. Painted signs are idiosyncratic rather than slick, and the subject makes a rewarding theme.

casual idea is the collection of hands at work, a few of which are shown here. This kind of shot crops up regularly in editorial assignments – moving in close to see how things are made, handled, collected. Not all are interesting, but some are quite unusual, and, when assembled together, they tend to enhance each other. The viewer makes connections and comparisons. Themes like these give direction and purpose to travel, even when they are just occasional asides.

Hands

Three of a large collection of close-ups taken in many different situations and countries, wherever there are hands doing something unusual or interesting. At the top, a Javanese farmer harvests rice stalks one by one, above a Bulgarian girl picks roses for perfume, and left a Balinese priest at a temple ceremony.

A three-day city shoot

Planning a walking route is one of the most effective ways of covering the important locations, and to save time this can be researched before arrival.

Why three days? From experience, this is the minimum time for a basic coverage of the main sights, although it calls for an energetic schedule. Day one is usually for familiarization, even while shooting. Whatever the preparations and research, every photographer has a different eye for things, and nothing beats an on-the-ground assessment of the most effective viewpoint and its timing. Sunlight, weather, and the daily round of activity all help determine the best time for shooting, and this may have to be left to the following day.

Cities have such a concentration of activity and sites – all of it easy to research – that they benefit from a plan of action. This translates into a series of routes, most of it on foot but using taxis or public transportation to move between sections of the city. How detailed the planning is depends on the photographer's style (some people feel constrained by a precise schedule) and on the purpose. If professional, the assignment may come with a shot list from the client, and the idea of the plan is to cover every location with economy of time while paying attention to the light and timing of certain events. In the example here, one day of a trip to the heart of London, the Changing of the Guard at Buckingham Palace takes place at precisely 11:30 in the morning, and much of the rest of the day hinges on this.

It is important to allow room for the unexpected, so a plan such as the one shown here is divided into zones, and the idea is to wander around the back streets as well as the main thoroughfares, alert for whatever may happen. And if something of special interest turns up, the entire plan may simply be jettisoned.

Mapping the schedule
A marked-up street map (top right) shows the plan of attack for part of one day in central London. The aims are specific according to the needs of the assignment – in this case including details of traditional signs and shop windows around Piccadilly, and a formal photograph of County Hall. The timing is keyed by the daily Changing of the Guard and by sunset. Not shown here, for reasons of space, is the afternoon, spent in the financial district (the City of London) before returning to Westminster for the architectural shot.

CITY LIGHTS

For a night-time shot, consider the floodlighting and window lights. Cities are more brightly lit after sunset than before sunrise, and more so in winter than summer. Different types of light – street lighting, neon displays, and public building floodlights – are switched on at different times, usually automatically. Few people locally know these times, although for a specific building caretaking or security may be able to tell you. Otherwise, make a recce the evening before. This timing is important because, as in the example here, the best time is usually at dusk, when there is still sufficient light in the sky to reveal the building's outline.

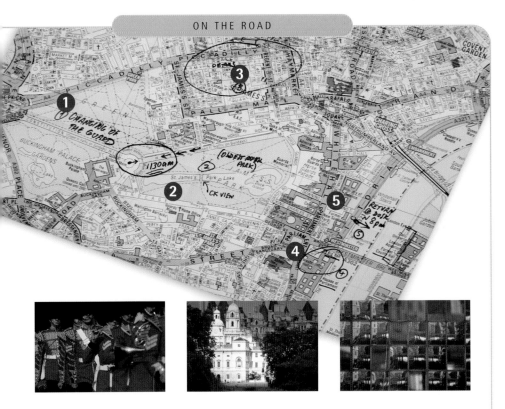

1 Changing the Guard

Weather permitting, this takes place at 11:30a.m., and the short route is always the same. The viewpoint has been chosen in advance, and because the event attracts crowds of tourists, the photographer plans to be in position at least half an hour beforehand.

2 Whitehall from the Park

St. James's Park is the oldest of London's several royal parks, founded by Henry VIII, definitely worth photographing and a convenient location for when the Changing of the Guard has finished. There are classic views of Whitehall and Horse Guards' Parade.

3 London bus

Piccadilly is just ten minutes' walk north of St. James's Park, and is a major tourist spot. The photographer had in mind a different approach from the usual – concentrating on details. Here, the bottle-glass of an old window offered repeated, distorted reflections, and a different take on the red double-decker bus, one of London's symbols.

4 Wine merchants

The small streets around Piccadilly are crammed with traditional shops, some dating back two centuries and more. The plan was to hunt out obscure details, such as this hand-painted gilded lettering on a door that has been endlessly repainted.

5 Big Ben

Some city sights are so well-known as to offer almost nothing new to the photographer. Nevertheless, they may simply have to be done – in this case, Big Ben, part of the Houses of Parliament. Fortunately, it had two things going for it on this day – good weather, and a tethered blimp, which at least added something unusual.

Event planning

Parades, processions, fairs, and other public showcase events offer some of the richest and most colourful possibilities for photography. There is never any shortage of scenes and people, and usually the only real difficulty is working your way around the crowds. Because of the high concentration of activity, the key to shooting comprehensively is planning. This means working things out well beforehand, and following a schedule, such as the following:

- The first step is finding out what events are on the calendar for the period you will be there. Before you travel, check in guidebooks, with whatever the local, regional, or national tourist organization is (website or telephone), and, if abroad, with the embassy. If the event is well-known, such as Mardi Gras, or the Palio in Siena, look for previous photography in magazines such as *National Geographic*. That will give you an idea.

- Most events are organized, at least to some extent. On arrival, contact the organizers and ask for a schedule. Other likely sources of information are the local newspaper, local guides, or the hotel.

- Once you know the structure and timing of the event, you can decide which aspects of it are worth covering, and whether you will have enough time to move from one place to another (in the case of a parade).

- Finding the right viewpoint for the right moment is essential. In fact, for the key shot (there nearly always is one for most events), viewpoint is everything. It is always worth putting in time checking this out a day or two before. Look around the site or the route to find the best vantage points. If the event is very

Fire ceremony on the Ganges

Each sunset at the holy town of Haridwar on the Ganges in northern India, a Hindu ceremony is performed by priests swinging braziers. The event is always crowded, but a little research earlier in the day identified an area on the opposite bank as ideal for an unobstructed telephoto view. To get a water's-edge position meant arriving an hour before.

Blenheim cross-country

The cross-country event, featuring a water crossing and brush jump, at horse trials at Blenheim Palace, England. A position high on the opposite bank, recce'd earlier, gave a clearer view with a long telephoto (300mm efl) than from a viewpoint closer to the jump. Head-on shooting also made it easier to get a sequence of frames.

Kingston Carnival

The annual Carnival in the Jamaican capital is full of colour and energy, best captured from the middle of the event. A talk with organizers established permission and also that there would be gaps between groups of dancers from where I could shoot towards the front of each.

popular and likely to be covered by the media, the best positions are likely to be reserved, but even then doing your own groundwork can turn up a free viewpoint. Also, there is no harm in asking if you can enter the area set aside for the press – even if you have no professional claims to a press pass, there is always a chance.

- Somewhere high, like a balcony, is often a good bet, allowing you a variety of images with different lenses. Even a slightly elevated position is useful for shooting over heads – if you are checking before the day, anticipate where other people will be. The disadvantage is that everywhere may be so crowded that you can't move. All of this depends on how big the event is. If you know you will have to stay in one position, take more equipment – a tripod, for instance, is useful with long lenses. On the other hand, if you are going to be on the move, take only what will fit into a bag.

- One of the best ground-level views of a parade is head-on with a telephoto lens. A bend in the road or a traffic island are likely to be good positions for an unobstructed shot.

Event shooting

Events offer several different kinds of image opportunity, and it's important to keep all of these in mind. Most turn on one or two key moments, such as the high point of a procession, so always try and make sure you get these. Nevertheless, don't ignore the other possibilities, which include the asides, the unpredictable events, behind-the-scenes preparations, and the faces and reactions of spectators. To cover as much as possible, you may need to make sure that you can move around, which may not be easy in heavy crowds. Also be prepared to move quickly from one focal length to another.

Preparations in the lead up to the event, which may take a few hours, even days, always provide many good opportunities. During these times, which include rehearsals, the pressure is usually off, participants are less keyed-up, and you will usually have much better access than during the event itself. This is the time to hang around and get the background. Immediately prior to a parade, participants will gather in one or more staging areas, and these too offer a particular kind of image.

The parade. This varies in style and organization from place to place, but there are usually some consistent features that lend themselves to these kinds of shot:

- **Long-shot from head-on**. Usually, this only works with the head of the parade or if there are distinct breaks between sections.

The Siena Palio
This violent and idiosyncratic horse-race takes place annually in the Tuscan city of Palio, dates back to the Middle Ages, and has not changed substantially in all that time. These four images are a small selection of the entire take, chosen here to illustrate variety and coverage.

Acrobatics
A long pageant precedes the race proper.

Preparation
Pageant participants being checked for costume and makeup.

MEDIA MANAGEMENT

Events encourage heavy shooting, and with digital there are no concerns about wasting too much space. The chief problem is having sufficient media capacity for the occasion. At the least, clear all your memory cards. In pauses during the day, when not much is happening, you could edit the images. Unless you have a large total capacity in your memory cards/microdrives, seriously consider taking a high-capacity, stand-alone portable storage device and downloading to that at intervals.

CROWD-BEATING TIPS

You may not want to go to this trouble, but if the shots are important, follow the professionals who do this kind of thing:
- A short, lightweight stepladder guarantees a clear view over the heads of other people (but may displease those behind you).
- Some professionals secure their viewpoint by chaining their tripod or stepladder to a railing or similar.
- You could hire someone to hold your place until you reach there.

- **Long-shot from above**, cropped in and compressed, showing a mass of people.
- **Wide-angle from close**, taking in the energy and the crowd reaction.
- **Close shot** of the main character/ float/centrepiece. You may need to react quickly and choose the right focal length.
- **Spectator reaction**. Turn to look at the spectators. Their reactions can make good images in themselves.
- **Details.** Look for close-ups, even extreme, of costumes, uniforms, decorations, and so on. Some of these may be quite special and only brought out for this occasion.

The race
No saddles and hardly any rules as the horses complete several circuits of the track in the main piazza.

Spectators
Shots back into the crowd are always useful – but only when there is a reaction.

An arranged event

Events always need to be organized by someone, so why not arrange your own? Now, organizing a situation for photography smacks of interference in the normal course of activity, with overtones of pretence. There is, however, the world of a difference between a setup that pretends to be real when it isn't, and a performance that is simply dedicated to one camera. Travel photography is for the most part concerned with how things actually are, with a strong dose of documentary, and the idea of an out-and-out set-up is anathema – where a photographer is trying to fool the audience into believing that here is a genuine, spontaneous slice of life when, in reality, the action has been stage-managed. But quite often, as we've seen, events are openly staged for people's enjoyment, and the photographer's usual problem is finding a vantage point for effective shots when there is an audience that also wants a good view of what is happening.

In this case, the performance in question was a traditional Khmer dance staged in the ruins of a twelfth-century temple at Angkor, Cambodia. Specifically, and what made it interesting, the gallery where the dances occasionally took place was originally built for that, with stone friezes high up on the walls showing the medieval dancers. The events were arranged by the World Monuments Fund, responsible for the restoration of this particular Angkorean temple. This was part of an assignment, and I knew what I wanted – a scene as close to the original as possible. That meant no twentieth-century tourists in view and a certain amount of theatrical direction. It also meant hiring the troupe myself. To extend the feature, I visited the dance school in town and photographed rehearsals there. On the day, I knew from experience that makeup and other behind-the-scenes activities were likely to provide some spontaneous moments.

Traditional dance
These images are selected from a shoot at a twelfth-century temple at Angkor, and at the dance school where the participants trained.

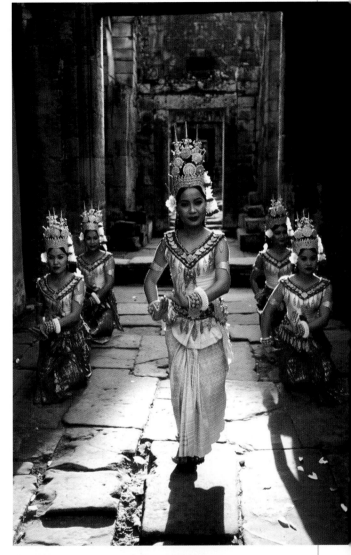

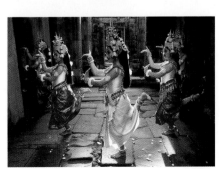

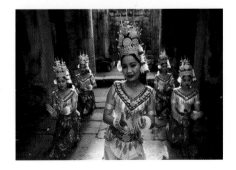

Vehicles

WELL, WHAT'S WRONG with public transportation? Renting cars and fourwheel drives might seem like an extravagance, but photographers have different needs from most other travellers. Opinions vary as to the value of shooting while on the move (see page 132, The journey). Personally I'm not so enthusiastic about public transportation as camera platforms, for two reasons. First, views through windows soon become monotonous, and while they certainly can make a good picture, you are not likely to want more than one or two per trip. Second, and more important from my point of view, coaches and trains won't stop when you see a good photo opportunity. I'm firmly committed to travelling by car whenever and wherever I can, and I budget for it. And if that budget allows, I would choose a vehicle that is easy to get in and out of, and has a flat roof strong enough to stand on – an elevated camera platform often comes in handy.

With self-drive, most car rental firms abroad will ask for an International Driver's Licence/International Driving Permit, which is acknowledged in more than 150 countries. This document, containing translation pages, simply confirms your qualification to drive, and is normally issued by touring and automobile organizations (UK citizens can get more information from the DVLA website at www.dvla.gov.uk). It is never valid alone or in your own country.

In less-developed countries, labour is cheaper than machinery, and you may find it hardly less expensive to rent a car with a driver than without. This is, frankly, the ideal, for provided that you have checked out both the vehicle and the driver before you sign the agreement, you have nothing to distract you from the photography. The driver can also double as a guide.

WHEN NOT TO SELF-DRIVE

In many less-developed countries, being involved in a serious accident in the countryside can quickly turn nasty, and on these occasions you do not want to be the foreign driver. Even in Thailand, for example, which you might expect to be a friendly, reasonable country, the commonplace view is that traffic accidents are the fault of the larger, more expensive vehicle. The standard newspaper phrase when reporting accidents is 'the driver fled the scene'. I wonder why.

CHECK THE VEHICLE

Surprisingly, few people pay sufficient attention to the condition of the vehicle they are about to rent. This matters whether you have a driver or it is self-drive. Check the tyres for tread and air pressure, check the spare tyre, the toolkit, lights, and horn. Clean, well-maintained bodywork also indicates the general level of care.

Out of road and traction
Dune driving needs skill, experience – and then luck, which here ran out when the lead vehicle sank into an invisible soft area of sand. This is where PSP (perforated steel plate) comes into its own.

PRIORITIES

We had been driving in South India for three days when the Tamil-speaking driver pulled over, clearly concerned, and began checking under the hood. I could tell from his demeanour that this was serious, but could not understand the name of the affected part, and everything seemed all right to me. The fault lay in the horn, and in India this renders a car virtually undriveable in towns – it may not be the law, but all drivers rely on the horn to warn each other of their presence. We had to have it repaired immediately at a garage in order to continue.

CHECK THE DRIVER

Particularly if you are renting for a few days, bear in mind that the driver will be your near-constant companion, so you had better be able to get on with him (and communicate with him). There are a few things worth establishing early on:

- In some countries with a tourist industry, drivers receive commissions from shops, hotels, even restaurants, which may tempt you to waste time visiting these. Explain right at the beginning that you don't want any of this.
- If you don't share the same language, at least learn the expressions for stop, slow down, left, right, straight ahead, let's go. Acquire more from a phrasebook as you go, but these should get you through the first day.
- The driver will probably find somewhere else to stay the night rather than at your hotel. Make sure you know how to find him.
- Ask the driver to fill the vehicle with petrol at non-urgent times – that is, not when you are dashing to find a sunset view.
- Establish the exact payment details: whether the charge will be based on time or mileage, and whether petrol, tolls, and driver's meals and accommodation are included, or are extra.

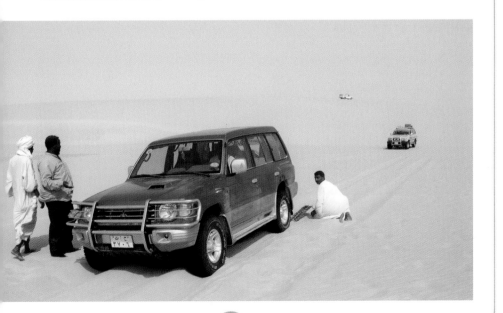

Aerials

AERIAL PHOTOGRAPHY has its own unique range of subjects, particularly if you shoot vertically downward for what can be unusual, abstract images. Patterns that are invisible on the ground can be the most striking part of an aerial shot. Lighting separates the good from the ordinary. Direct sunlight offers higher contrast than overcast weather and, being brighter, allows higher shutter speeds. The most reliably attractive light is from a low sun early in the morning and late afternoon – the shadows are longer and the texture of the ground well-defined. One of aerial photography's special problems is haze, because of the thickness of atmosphere through which you have to shoot. The simplest solution is to fly low (say, at about 300m/1,000ft) and use a wide-angle lens. A UV filter will help sharpen contrast and cut through the haze. A polarizing filter is even more effective, but needs more light and so a slower shutter speed.

The most useful aircraft is single-engined and high-winged, such as a Cessna. Flying time is relatively inexpensive, the aircraft is highly manoeuverable, and view unrestricted by the wings. If the window hinge is at the top, the retaining bar can be unscrewed so that the window can open fully – the airflow will hold it up against the wing. Not all pilots know this. With a larger, low-winged aircraft visibility is restricted, but one possibility is to remove the rear luggage hatch (the flight will be uncomfortable and probably cold). Helicopters are the ideal, but very costly; avoid including the rotor blades in frame – although almost invisible to the eye they will record clearly at a high shutter speed.

FAST SHUTTER SPEED

Aircraft vibration and buffeting contribute to camera shake. Use a high shutter speed (depth of field can be shallow) and do not rest the camera on any part of the fuselage – use at least 1/250sec or 1/500sec. Airflow through an open window makes focusing difficult – rely on auto-focus.

CONSIDERATIONS

- Plan the route. Use a map – an aeronautical one if possible – and mark on it the locations that interest you. Check with the pilot what the ground speed will be at the height at which you plan to shoot, and calculate the flight time.
- Choose the time of day. Check the weather reports, the best are likely to be at the airport from which you fly. Allow about half an hour to prepare equipment and the aircraft before takeoff.
- Brief the pilot. Show the map to the pilot, explain what the subjects are and agree whether you need a vertical or diagonal view of each. Agree procedures for banking and changing altitude.
- Prepare the aircraft. Explain to the pilot well beforehand (even the day before) your need for a clear view with no window. Windows or doors may need to be removed before takeoff. Adjust the seating and check the field of view.

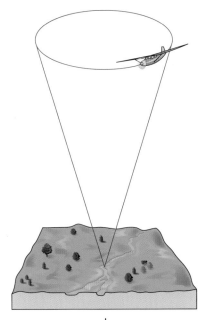

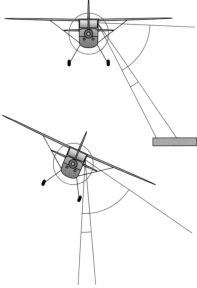

In the cockpit
The views from the helicopter cockpit are stunning. Make sure you can grab shots that offer clear views – from a window or the rear luggage hatch.

Helicopter for choice
The great manoeuverability of a helicopter makes it ideal for photography, though it is expensive. It can also land in restricted spaces, as here in Irian Jaya, the western part of the island of New Guinea.

Shooting angle
This varies from aircraft to aircraft, but is always restricted to some extent. Shooting vertically down in level flight is usually impossible, so that to circle a target effectively, the pilot needs to make a circle around it rather than fly directly over it. The field of view varies with the focal length, and is greater and so more restricted with a wide-angle lens (lower illustration) than a telephoto (upper).

Dealing with obstructions

THE WORLD IS NOT FULL OF PERFECT VIEWS, and travel photography would become boring if every scene was just so. Nevertheless, there are times when you really want an unobstructed view of a special place, and it can be frustrating to find that the monument you planned to shoot is under scaffolding. Time was when you would have to resign yourself to the loss of a picture. Digital imaging, however, provides the means to restore a scene, and most people are already familiar with the cloning and retouching tools in Photoshop. Here is not the place for detailed instruction in image retouching – there are other books for that, such as *The Complete Guide to Digital Photography* and *Digital Photography Special Effects*. The important thing when you're standing in front of an obstructed view is to know what can be done digitally and how to shoot for it.

Think of instructions in terms of their removability, which varies. If the obstruction is at some distance from your subject, it may be possible to move right up to it and shoot wide-angle. Alternatively, a power line that hangs right in front of you from your first choice of viewpoint may, from a distance, reduce to insignificance or be hidden by something innocuous like trees.

When you've done your best on the ground, it's time to plan for the digital retouching, and you can make useful preparations. In nearly all cases, removing obstructions digitally means cloning from elsewhere in the image, so these clone sources are the parts to think about. A patterned surface, such as brickwork, is relatively easy to use, but check carefully what the obstruction is covering. If it is hiding a unique feature, such as the doorway of a building, then consider

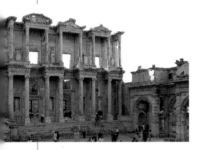

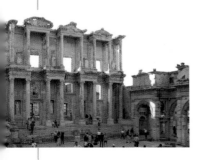

1 A constant crowd
This Roman monument at Ephesus, Turkey, was immensely popular. I spent ten minutes shooting the identical framing several times.

2 Layered removal
Placing each image in a stack, the people were removed with an eraser brush. Because they were moving, what was obscured in one layer was visible in another.

moving the camera slightly. The principle is to choose the viewpoint so that, as much as possible, only clonable areas are hidden.

Even more effective is the parallax system for retouching. For this to work, there has to be some distance between obstruction and subject, so that shifting the viewpoint to one side actually has a parallax effect, revealing different parts. Scaffolding built close to a building responds poorly to this technique. The ideal result is a pair of near-identical images, but with the parts that are obscured in the first shot revealed in the second. The digital technique is then extremely straightforward; it consists of placing one image in a layer over another and erasing selectively.

A different version of this system that involves more work is to shoot the obscured areas separately, moving closer to do so where necessary. Although the scale is then different, as long as the resolution of these individually photographed patches is no less than that of the main shot, they can be downsized digitally before pasting in.

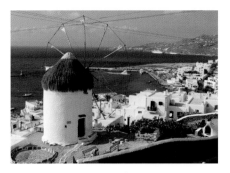

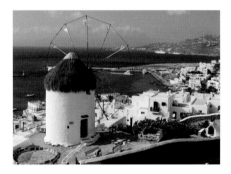

Power and telephone lines
This view of an old windmill on Mykonos was marred by cables across the upper part of the image. And the viewpoint was greatly restricted, making them impossible to avoid. The solution was an hour of retouching, using the Clone Tool and Healing Brush.

3 Flattened composite
The holes in each layer created by people removal were automatically filled by the revealed parts of the monument in another layer, and the final composite shows an emptied site.

Forward digital planning

THE DIGITAL SOLUTIONS to obstructed views on the previous pages are just one example of an essential difference between digital and traditional film cameras: the photography does not end with the capture of the image. Formerly, the moment of pressing the shutter button effectively closed the process. The image, even though latent on unprocessed film, was locked, and could be altered only with considerable effort. A digital image, in contrast, waits for further manipulation, and that is by no means restricted to optimizing brightness and colour, or sharpening. The final image is whatever you decide it should be. Postproduction is the term used for the work performed on images after shooting to turn them into their final form for presentation and viewing. Think of it as an extension to shooting.

Indeed, taking full advantage of the freedom and flexibility offered by digital capture calls for a different approach to photography itself. And, as with travelling and travel photography, the principle is forward planning: shooting now with a view to what can be done later. This is always likely to affect a minority of travel photographers, and I'm not suggesting that alteration and manipulation should be standard, but there are already several established possibilities, with new ones waiting to be discovered.

2 Raw brights
From the same single shot the first image was opened in Raw underexposed, for the highlights.

3 Raw darks
A second version was then opened in Raw, but overexposed, for shadow detail. This was pasted on top in its own layer.

1 Managing difficult contrast
Part of digital shooting is knowing what can be done later – and preparing for that work. Here, the juxtaposition of a huge religious monument and tilting power cables in Japan was appealing, but the weather and lighting were unhelpful. But I knew that this could be dealt with provided that I shot in Raw format and avoided overexposure.

The established routes include digital removal of unwanted objects, as we've just seen, and also conversion to black-and-white and panoramas, both of which are dealt with on the following pages.

Other possibilities suggest themselves. For example, photographing the identical scene under different lighting conditions provides interesting material for subtle digital manipulation. With just a pair of shot versions, sunlit and cloudy, you can create any combination of the two. Superimpose one over the other in perfect register, as two layers in an image-editing program, and use a paintbrush or eraser to create the effect of a burst of sunlight illuminating just a part of the subject. With more images in register, the choices are increased.

The same technique is useful for handling a high range of brightness, such as on a bright cloudy day when a correctly exposed landscape leaves the sky washed out and white. In this case a second exposure, a few stops darker, to record sky detail, can later be combined with the first shot. Shooting a series of near-identical images also suggest the possibility of displaying them as a sequence.

4 L.A.B levels
The light version was then converted to Lab mode, the Lightness channel given extreme contrast by adjusting Levels, and this turned into a selection – in effect a highlight mask.

5 Composite
After loading the highlight-mask selection into the upper, brighter layer, the Delete button was hit, creating a composite that preserves all the important tones and colours.

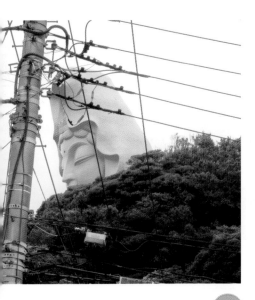

OBSTRUCTION REMOVAL

As described in more detail on the previous pages, it is always possible to retouch a partially obscured subject provided that you change the viewpoint sufficiently for a second shot that takes in the hidden areas. In other words, use parallax to capture everything, even though it may be on two or more frames. The later work – here cutting and pasting to eliminate scaffolding – is likely to be time-consuming, however.

Switching to black-and-white

MOST DIGITAL CAMERAS offer the option of shooting in monochrome, and although most camera owners ignore this setting, it has exciting possibilities. Black-and-white photography is by no means a reduced version of full colour. In terms of composition, lighting, and graphic texture it works in a substantially different way, and switching from colour to monochrome calls for rethinking your visual approach.

By restricting the means of recording images to a range from white through greys to black, it gives special importance to the modulation of tones. This in turn gives stronger meaning to shape and line. With the image constructed entirely in greyscale, the viewer's eye pays more attention to texture, too. Black-and-white is capable of great subtlety. As a rule, scenes in which the main visual interest is in pattern, texture, silhouettes, or the contrast between different shapes, are candidates for thinking in black-and-white.

However, even if you have shot in colour, you can still convert the image to monochrome by discarding colour information. Better still, having the resource of RGB allows you to control the tonal values of an image with precision. This is still possible, but not necessary (see panel, opposite).

Black-and-white has always offered great control over the image, and in film photography the darkroom was a place for the kind of tonal manipulation that is now commonplace in digital photography. Indeed, monochrome digital images are still a ruthlessly realistic medium. Printing the image of the ruined stone temple (below) for brooding atmosphere would not have been possible in colour.

Automatic desaturation
The default methods of removing colour in Photoshop are to choose either Grayscale from Image>Mode or Desaturate from Image>Adjustments. They have essentially the same result, which is to assign equal values of red, green, and blue to each pixel.

More evocative in monochrome
The rich complexity of shadows and the texture of carved stone at the temple of Bayon in Cambodia carry more weight without the distraction of colour. Here, black-and-white allows the eye to savour tonal variety and subtle differences in the surfaces of the ruined monument.

Channel mixer

By checking the Monochrome box of the Channel Mixer, you can adjust the channels and simulate using a filter.

Dark red

With a high red value, and low blue one, the sky is darkened. An almost moonlit effect is achieved, like the Wratten 29 filter (see box).

Strong blue

The high blue value cancels out blue in the image, whitening the sky. In contrast, the yellow tones in the rocks are made richer.

COLOURED FILTERS TO CHANGE TONES

Because black-and-white film records colours as shades of grey, you can change their appearance by using strongly coloured filters. If you photograph a green leaf through a green filter, it will appear almost white; through a filter of its opposite colour, red, it will look virtually black. The same applies to objects in other colours – use the same colour filter to lighten them, the opposite colour filter to darken. The effect only works well with strongly coloured subjects – a lot of dark green vegetation, for example, does not respond, as its colour is not pure. The table below lists the most common filters and their uses:

Kodak Wratten no.	Colour	Effect	Extra exposure needed (f-stops)
8	Pale Yellow	Makes blue sky appear natural. Reduces haze.	23
15	Deep Yellow	Darkens blue sky. Reduces haze.	1 13
21	Orange	Darkens blue sky strongly and increases contrast outdoors. Darkens green vegetation. Lightens skin blemishes.	1
25	Red	Darkens blue sky dramatically, increases contrast, and deepens shadows outdoors (gives moonlit effect if slightly underexposed).	2 13
29	Dark Red	Even more extreme than Wratten 25, darkening pale blue sky on horizon.	3 13
47	Blue	Exaggerates haze, increasing sense of depth in some landscapes. Turns blue sky white. Darkens yellows.	2 23
58	Green	Lightens greens, including vegetation. Darkens reds.	3

Panoramas

THE TERM PANORAMA is used for wide horizontal views, and the hidden inference is landscape of one kind or another. They can be as wide as a full 360° circle, but in print they normally have proportions of between 1:2 and 1:4. Longer than this appears thin and a little uncomfortable to view. Such a long format, trimmed top and bottom, gives the eye a chance to roam around the picture. Just as in real life, the viewer does not take in everything at a single glance. Instead, you discover different things within the picture, even if this takes only a few seconds. This alone draws people into a panorama, and helps to make it more interactive than a normal image. It has something of a 'wrap-around' feeling.

A panoramic frame is surprisingly easy to use for composition. Even if the scene itself doesn't seem to be so horizontal, the frame can act like a storyboard, with things going on in different parts. It even works to have the frame 'divided' into panel-like areas. It usually helps if you can include plenty of detail or events in the frame, so that the eye has every opportunity to explore.

What makes it so relevant to digital photography is the software available to join a strip of separate images into one seamless, almost endless view. This has proved so popular that digital camera manufacturers now routinely include so-called 'stitching' software in the package that arrives with the camera. There are in

Shooting sequence
Using the camera setup shown, a sequence of five overlapping frames was taken. An overlap between each of about 40% helps the stitcher software to find enough corresponding points.

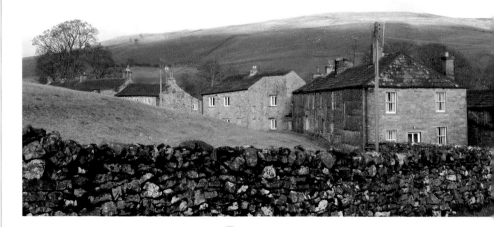

addition specialist stitcher programs that offer advanced features and simplify the procedure. The one used here is Stitcher from RealViz.

The sequence is simple. Begin with an overlapping horizontal of images shot from the same spot. The overlap should be at least one-third between each pair of frames. The stitching software needs to know this in order to find common points in neighbouring images, to merge them.

Stitching
The images are loaded in order into the stitching program, which then warps each to fit the others, then equalizes the tones for a smooth blend, and finally renders the panorama as a TIFF or JPEG file.

Cultural restrictions

GENERALLY SPEAKING, too much is made of exotic, arcane differences in behaviour between cultures – notably by publishers selling guides to the travel market. Crass is crass in most societies. A typical example is the advice never to pat a Thai on the head; well, patting anyone on the head is a little odd, particularly if you don't know them extremely well. As a rule, polite behaviour works universally, and is no bad thing to exercise all the time.

However, photographers are, by the nature of what they do, usually intrusive. In other words, we in particular have a tendency to push the limits of what is allowed and what is acceptable in order to get closer or capture an image that seems to us to be striking (some photographers more than others). Bear this in mind when in a different culture, as doing something which may be just acceptable in your own society – a slight breach of politeness that is nevertheless recoverable with a smile – may go too far elsewhere.

You will be forgiven minor or esoteric cultural gaffes unless you have already managed to annoy people in other ways. Major ones should be obvious, but are outlined here in any case. The principal exception to all of this is in countries which are undergoing some periodic upheaval in their society, politics, or economy. A wave of religious fundamentalism, for example, may last just a few years, but during that time many people are likely to be highly sensitized to behaviour that does not comply. You should be aware of this from your basic destination research (see pages 16–17, Researching locations).

Customs

- **Footwear indoors:** In many Buddhist countries, Japan (where the custom is only partly related to Buddhism), and some minority tribal societies, shoes should be removed before entering houses, places of worship, and some other interiors. The custom has two sources: in Buddhism, the head is the highest part of the body, the feet lowest, while practically it prevents dirt from outside from being brought in. In Japan, indoor footwear is provided (with yet another set for the bathroom).

Social issues

- **Poverty:** Scenes of people living in poverty reflect badly on the government, and in nondemocratic or less-democratic countries you may encounter objections, from those you are photographing, other people, and even the police.

Footwear
Many Asian countries have a deeply ingrained custom of removing shoes in religious places and even in homes.

Poverty: Colombia
Gamines – homeless children sleeping rough – in Bogota. Photographing these boys and their daily life meant first gaining their trust.

- **Sickness:** AIDS victims in countries where the disease is rampant.
- **Politics:** Riots are of course dangerous, and demonstrations can turn violent.
- **Ethnicity:** Some countries have internal racial problems, and this includes tribal conflict (a number of African countries, for example) and minority peoples. Some minority people even quarantine themselves from outsiders, photographers especially, for example the Hopi in the southwestern USA.
- **Dress:** Traditional dress, while actively celebrated at festivals and parades, may in some countries at some times be considered a sign of 'backwardness'. It is also, of course, connected to ethnicity problems (above), and to religion (below).
- **Prisons:** Of obvious sensitivity. A very few countries (including Burma at the time of writing) put prisoners to work outside prisons. This is also a sensitive issue.
- **Gender:** In some societies with unequal rights between genders, you may encounter problems photographing women, particularly if you are a man. If in doubt, ask beforehand.

Poverty: India
Part of a normal day on the streets in Old Delhi, but be aware that other people, in particular police, are likely to object if you spend too much time on shots like this.

Conflict
Arms are a way of life for the Pathan tribesman in Pakistan's Northwest Frontier, and as arms are dangerous, it's better to ask first before using a camera.

Muslim school
Girls in an Islamic school in Singapore. Religion and dress can together be a sensitive issue – again, essential to clear permission first.

Religion

- **Christian:** Few restrictions in mainstream Christianity, although sects tend by their nature to isolate themselves (Mennonites, for example). As with any religion, if you want to photograph inside a place of worship during prayers, mass, or any ceremony, ask first.
- **Muslim:** Generally restrictive for photographs, in some places extremely so. Much depends on the country (Indonesia, for example, tends to be more relaxed than Pakistan), but it is wise to start from the assumption that photography may be banned in the interiors of mosques. Ask and you may be pleasantly surprised. In strict Muslim societies where women are veiled or otherwise shrouded, it is a good idea not to photograph them.
- **Jewish:** The stricter sects will not want to be photographed.
- **Hindu:** As Hinduism is not a single unified religion, restrictions depend on the deity worshipped and on the particular temple. In general, inner sanctuaries where the principal image resides prohibit photography. A number of temples also forbid entrance to non-Hindus.
- **Sikh:** In general Sikhs welcome non-Sikh visitors, and there may be only a few places where photography is prohibited – and these will be signposted.
- **Jain:** Generally relaxed about photography with a few exceptions – certain images and Mount Abu.
- **Buddhist:** As one of the world's most tolerant faiths, Buddhist sites are almost all open to photography. Nevertheless, there are mores regarding feet (never sit so that they point toward a Buddha image or another person) and heads (never touch that of a Buddha image).
- **Shinto:** This Japanese faith places restrictions on entry and photography to the inner sanctuaries at the principal shrine, Isé. Otherwise, generally open.
- **Animist:** Many minority peoples worship spirits and deities connected to the land, sky, and natural features. Restrictions are local to communities. Enquire first.

A FEW TIPS

- If in doubt, watch what other people do first. (Isn't that what your mother taught you at the dining table?)
- Smile a lot.
- Don't draw unnecessary attention to yourself.
- If you think you've really made a faux pas, move away.
- Don't display anger. Vent any of your frustrations later.
- Display good manners.
- Be polite and friendly.
- Polaroids.
- Learn a little of the language.

Veil
In many Islamic societies, women are veiled. Not only this, but photography absolutely requires prior consent, as in the case of this Rashaida woman in eastern Sudan.

Cremation
Open-air cremation is a Hindu custom. In general, don't photograph one. An exception here was the public cremation of a member of the Nepalese royal family.

Tripod restrictions

ONE OF THE IRRITATING RESTRICTIONS for photographers is that against tripods. The reasons behind this pervading restriction are partly to prevent damage, but mainly to curtail professional photography, which is seen as exploitative (see Legal Restrictions, page 120). The people employed to oversee the site have their instructions, and the best you can hope for is that they look the other way. Pointing out that the tripod legs are rubber-tipped never works.

It is a good idea to be prepared, but without alerting attention. Examine signs and any printed material available. If you know in advance that a tripod will not be allowed, you can plan for it. You should use your judgement of the local conditions. One thing to do is simply to use your tripod until someone stops you.

Beyond this, there are a number of strategies that depend on the specifics of the site and attitude of staff. You can use a mini-tripod, placing it on any convenient raised surface – yes, it's still a tripod, but not so visible at a distance, so you may get away with it. The difficulty here is finding an elevated surface in the right position, otherwise you may be reduced to shooting from ground-level, with all the perspective problems of tilting the camera upward. However, one of the special uses of a mini-tripod is against a vertical surface, as shown in the shot, above right, of a Buddha.

An alternative is to attach the camera to a tripod head, but detach the tripod itself. Many cameras are light enough to sit stably on just the head, or consider some kind of baseplate. These are available from camera dealers, but it isn't complicated to construct your own by fixing a tripod bush to a block of wood. Again, the problem remains of finding a suitable surface on-site. There is, however, a lens solution to this. A shift lens (also known as perspective control) allows you to place the camera close to the ground, levelled horizontally yet still capable of eliminating the ground from the view, as in the photograph of a rock-cut cave temple opposite. Another nontripod solution is a clamp, although the chances of being allowed to use one on anything are slim.

If none of the above works, you might consider trying to tip the guard, but be careful, as this can easily be construed as an attempt to bribe!

Against a wall
A pocket tripod has a special use in that it can be jammed against a vertical surface for long exposures. This technique was used in this cave at Ajanta, India, to photograph a reclining Buddha, above right.

Baseplate and tripod head
Following the letter of tripod restrictions rather than the spirit, a head screwed onto a baseplate – itself screwed to a block of wood – makes a solid, low mount. How this is interpreted by guards at a restricted site may vary.

On the ground

Shooting from ground level is the final option when tripods are forbidden and the light is too low for handheld shooting, as in the case of this other rock-hewn cave at Ajanta. Placing the camera on a bag or anything padded helps to steady it...

...while you might be able to get away with a pocket tripod if no-one is looking too closely. In either case, use the Perspective Tool when image-editing to restore verticals.

Legal restrictions

BY DEFINITION, these vary by country, although common sense is, as usual, a good guide. The issues that are of most importance to photographers are security, trespass, and usage rights. The first of these can really get you into trouble, as all countries take military and police matters seriously. Basically, avoid taking photographs of, or even suspiciously near to, military installations such as barracks, airfields, training areas, and naval dockyards. Pay attention also to signs forbidding photography.

Some countries stretch the definition of military locations and those related to national security. It is quite common for airports and docks to be prohibited subjects, and in India, for example, bridges. Nuclear power stations, dams, and even some factories may also come under the definition. In a number of countries, airports are used partly by the air force, and you should ask yourself if you really need a picture of the fighter aircraft on the other (military) side of the international airport. Probably not (and certainly not in Greece).

In civil law, the two issues that you are most likely to come up against are intrusion and unlawful use of the photographs. It is important to understand that these are separate – the first affects whether or not you can take a photograph in the first place, the second whether you can make money from it later. The law varies between countries,

Armed forces
The only time you should shoot military equipment is on public display, such as at an air show or, as here in Tokyo Bay, a naval review, for which passes have been issued.

AMATEUR VS. PROFESSIONAL

Places that are open to the public but at the same time controlled, such as monuments, archaeological sites, theme parks, and so on, usually distinguish between amateur and professional photographers, largely on the ground of what they expect the photographer to do with the images. This makes it a grey and vague area, and in their attempts to prevent professional photography, the organizations that run such places often make arbitrary restrictions, which include:

- Use of a tripod (see page 48).
- Large or large-format cameras.
- Large lenses.
- Photographic lighting.
- Anything that gives them the suspicion that you might be professional, such as a metal case or large quantities of equipment.

as does the extent to which it is upheld. The USA, for example, is notably litigious, whereas many other countries, which have similar legal protection for intrusion and privacy, are more tolerant in practice. As a rule, trespass involves entering private property without permission. You may also in some countries be prevented from taking a photograph into private property from an adjoining public place. Nevertheless, if you have mistakenly trespassed and shot, there is hardly ever justification for a security guard to seize your camera. In such cases, the police may be your best resort.

As a photographer, you automatically own the copyright in the images, but not the subjects you have shot. This is key if you sell the photograph for purposes of trade. It does not apply if the photographs are for your own use, or if they are published editorially. The possible confusion here is that you can, of course, earn money for editorial use, but in most countries the law recognizes this as fair use. 'Commercial' in this case means using a photograph to sell a product.

Unambiguous
No excuse for ignoring this sign, in six languages and with consequences illustrated.

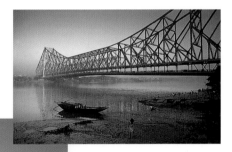

Bridges
Unreasonable though it may seem if you are from another country, some nations, such as India, treat bridges as essential to national security and forbid photography. If you must, be quick.

Copyrighted buildings
Taliesin West, built by Frank Lloyd Wright in Arizona, is a good example of a building that, while open to the public, severely restricts photography and the use of photographs. Written permission is needed.

Releases

ONE FORM OF INSURANCE against legal problems in using a photograph commercially is to acquire a signed release – for a person a model release, for a place a property release. These documents, when signed, are effectively permissions granted by the person or owner for you to use the images commercially. Remember that for your own personal use, or for editorial use, you do not normally need a release. These releases are for use for commercial gain, which includes advertising and stock photography. In the stock photography world, images are often marked with one of the following abbreviations:

MR Model released
PR Property released
NR Not released (or NMR, NPR)

There are also many images – the majority – in which a release is either not necessary (a landscape, for example), and this would be 'Not applicable', or where a person in the image is too small or indistinct for it to apply ('Not recognizable').

Included here are a short release, full adult and minor releases, and a property release. The problem, as you can see by reading through them, is that presenting a document like this to someone who has no experience of them may be daunting, and cause them to refuse when they otherwise might have been agreeable. These documents are available for download from this book's website (see page 168).

MAKING LIFE DIFFICULT

At a certain point, the lawyers at Time-Life decided that all photographers should carry a sheaf of model releases on assignment. This followed some (failed) attempts by people who had appeared in book publications to extract money from the company. So, shooting in Indonesia, having managed to get a good candid picture, I was then supposed to ask the surprised subject, who often neither spoke nor read English, to sign a document giving us the right to do whatever we wanted with the picture, for no payment. As well as being unnecessary (see the main text), it was a dismal failure, and soon abandoned.

MODEL RELEASE

In exchange for consideration received, I hereby give permission to _____ to use my name and photographic likeness in all forms and media for advertising, trade, and any other lawful purposes.

Print Name: _____

Signature: _____

Date: ____/____/_____

(If Model is under 18) I, _____, am the parent/legal guardian of the individual named above. I have read this release and approve of its terms.

Print Name: _____

Signature: _____

Date: ____/____/_____

ADULT MODEL RELEASE

In consideration of my engagement as a model, and for valuable consideration hereby acknowledged as received, I hereby grant _____ , his heirs, legal representatives and assigns, those for whom _____ is acting, and those acting with his/her authority and permission:

a) the absolute unrestricted right and permission to copyright and use, re-use, publish, and re-publish photographic portraits or pictures of me or in which I may be included, in whole or in part, or composite or distorted in character or form, without restriction as to changes or alterations, in conjunction with my own or a fictitious name, or reproduction thereof in colour or otherwise, made through any and all media now or hereafter known for illustration, art, promotion, advertising, trade, or any other purpose whatsoever.

b) I also permit the use of any printed material in connection therewith.

c) I hereby relinquish any right that I may have to examine or approve the completed product or products or the advertising copy or other matter that may be used in conjunction therewith or the use to which it may be applied.

d) I hereby release, discharge and agree to save harmless _____ , his/her heirs, legal representatives or assigns, and all persons acting under his/her permission or authority, or those for whom he/she is acting, from any liability by virtue of any blurring, distortion, alteration, optical illusion, or use in composite form, whether intentional or otherwise, that may occur or be produced in the taking of said picture or in any subsequent processing thereof, as well as any publication thereof, including without limitation any claims for libel or invasion of privacy.

e) I hereby warrant that I am over the age of majority and have the right to contract in my own name. I have read the above authorization, release and agreement, prior to its execution, and I fully understand the contents thereof. This agreement shall be binding upon me and my heirs, legal representatives and assigns.

Print Name: _____

Signature: _____

Date: ____/____/_____

Address:_____

Witness:_____

PROPERTY RELEASE

For valuable consideration hereby acknowledged as received, I the undersigned, being the legal owner of, or having the right to permit the taking and use of photographs of the property designated as

hereby grant to _____, his/her agents or assigns, the full rights to use such photographs and copyright the same, in advertising, trade, or for any other lawful purpose.

a) I also permit the use of any printed material in connection therewith.

b) I hereby relinquish any right that I may have to examine or approve the completed product or products or the advertising copy or other matter that may be used in conjunction therewith or the use to which it may be applied.

c) I hereby release, discharge and agree to save harmless _____ , his/her heirs, legal representatives or assigns, and all persons acting under his/her permission or authority, or those for whom he/she is acting, from any liability by virtue of any blurring, distortion, alteration, optical illusion, or use in composite form, whether intentional or otherwise, that may occur or be produced in the taking of said picture or in any subsequent processing thereof, as well as any publication thereof, including without limitation any claims for libel or invasion of privacy.

d) I hereby warrant that I am over the age of majority and have the right to contract in my own name. I have read the above authorization, release and agreement, prior to its execution, and I fully understand the contents thereof. This agreement shall be binding upon me and my heirs, legal representatives and assigns.

Print Name: _____

Signature: _____

Date: ____/____/_____

Address:_____

Witness:_____

MINOR MODEL RELEASE

For valuable consideration hereby acknowledged as received, I the undersigned, being the parent/legal guardian of the minor child named below, hereby grant _____ , his heirs, legal representatives and assigns, those for whom _____ is acting, and those acting with his/her authority and permission:

a) the absolute unrestricted right and permission to copyright and use, re-use, publish, and re-publish photographic portraits or pictures of the below-named minor or in which the said minor may be included, in whole or in part, or composite or distorted in character or form, without restriction as to changes or alterations, in conjunction with the said minor's or a fictitious name, or reproduction thereof in colour or otherwise, made through any and all media now or hereafter known for illustration, art, promotion, advertising, trade, or any other purpose whatsoever.

b) I also permit the use of any printed material in connection therewith.

c) I hereby relinquish any right that I may have to examine or approve the completed product or products or the advertising copy or other matter that may be used in conjunction therewith or the use to which it may be applied.

d) I hereby release, discharge and agree to save harmless _____ , his/her heirs, legal representatives or assigns, and all persons acting under his/her permission or authority, or those for whom he/she is acting, from any liability by virtue of any blurring, distortion, alteration, optical illusion, or use in composite form, whether intentional or otherwise, that may occur or be produced in the taking of said picture or in any subsequent processing thereof, as well as any publication thereof, including without limitation any claims for libel or invasion of privacy.

e) I hereby warrant that I am over the age of majority and have the right to contract on behalf of the said minor. I have read the above authorization, release and agreement, prior to its execution, and I fully understand the contents thereof. This agreement shall be binding upon me and my heirs, legal representatives and assigns.

Minor's Name:_____

Parent or Guardian:_____

Signature of Parent or Guardian:

Date: ____/____/_____

Address:_____

Witness:_____

The daily edit

THERE ARE TWO BASIC PURPOSES IN EDITING a take of photographs: to discover the best, and to organize them into related groups. This done, the images are in principle ready for use, whether personally, editorially, or commercially. I use the word 'discover' deliberately, because the process of reviewing, analyzing, and comparing photographs is a creative process in its own right. What you achieve might be different from what you set out to shoot, and as visual surprises are the diet of photography, particularly when travelling to new destinations, you can expect to change your mind as you sift through your results. On pages 72–73 we looked at the means of editing, both hardware and software. Here we deal with the method, and Basic editing procedure, opposite, shows one set of steps.

Digital photography shifts the editing goalposts, because you can perform these steps on the spot, or at least at the end of the day. In other words, you can have regular feedback as to how your entire travel shoot is going, and make the necessary changes. If it seems partway through a trip that you are lacking images of local people, then you can start to remedy this immediately. To the original aims of selecting the best and grouping related images, digital photo-editing adds a third: guiding the creative progress of the shoot.

There remains, however, one real danger in on-the-spot editing. It is actually too easy to throw images away, and once you have bought into this different shooting culture with its overshooting for safety and choice, you are likely to feel compelled to discard a proportion of the images. Certainly, this daily assessment can sharpen your eye for editing, but it may be dangerous to feel obliged to make fast decisions. We often come back to images that we may not have rated highly at the time to discover that they do have value after all. See Digital rejects, below.

DIGITAL REJECTS

Until you reach the point of having no room whatsoever for storage, I recommend as a precaution that when you discard images during editing you place them in a special Rejects folder rather than fully delete them. You can revisit the folder later and delete then.

Laptop editing
If you plan to do more than simply review the daily take, a laptop is essential. Begin by downloading the images either directly from the camera or from a card reader. Most laptops use a USB2 port for this.

BASIC EDITING PROCEDURE

Irrespective of where you do this, photo-editing invokes certain skills and sensibilities. Editors and photographers have different procedures, but the following is reasonably standard:

- Throw out all technically incompetent shots (wrong exposure, blur, shake, etc.). By 'throw out' I mean, of course, put in a Reject folder (see panel).
- Discard images that are awkward, in the sense of a clumsy arrangement or moment, such as someone blinking. Again, see the panel on Digital rejects.

- Group sequences and very similar images of the same subject.
- Mark or flag in some way (depending on your editing software) the best one or two images in each of the sequences, and the best among all the other images. These images are the 'selects'.
- If your editing software allows several folders or catalogues containing copies of the same image, open some with themes relevant to the trip, for example 'People', 'Landscapes', 'Colours', 'Markets'. Place copies of appropriate images in these.

Browser procedure

On your browser of choice, use flagging/tagging to mark selects and other groups of images. These can then be displayed on their own either in the same folder or as copies in secondary folders dedicated to particular groupings.

17797.37-TRAP-pg

Notes and captions

Why BOTHER to keep notes? Surely this interrupts the creative flow of the shooting, besides being something of a chore. The answer lies in the nature of travel photography. Basically put, the value of the information needed to plan a trip and prepare for all the picture opportunities is the same for the photographs that you bring back. Most travel photography is heavy on content – the what, who, and where of it all – and in travelling to new destinations there is always a lot to discover and learn. The name of this temple, the location of a hidden beach, the date and significance of a special ceremony: there is likely to be a constant stream of facts accompanying your photographs, and the details are normally available there and then. Noting them on the spot, either in a notebook or with a small tape recorder, will save a lot of trouble later trying to retrieve information that you have forgotten.

PHOTOGRAPH THE LABEL

In situations where objects are labelled, the easiest way to record the information is to take a shot of the label. Do this immediately after or before the main photograph, but be consistent as to which, particularly when shooting a series of objects, such as plants as in this example at a nursery.

W 964702-A

HYDRANGEA
PANICULATA
'UNIQUE'

EMBEDDING CAPTIONS

For little extra effort, a caption can be attached to a digital image so that it stays with it and is always accessible. In the example below, essential information is entered into File Info in Photoshop, but the procedure is similar for other image-editing programs. The windows have many entry fields, but the three most important for photographers are the copyright, the caption, and keywords. All this information can be extracted by image-management programs and other databases. The time to enter the captioning is as early as possible in the inevitable chain of image versions and copies. My own method is to maintain a master caption list in a word-processing program, then to copy each entry as soon as I've written it into Photoshop's File Info. When I then catalogue the image in Extensis Portfolio, the information appears automatically. Even better from my point of view is that when I upload the image to the server that hosts my commercial website, it immediately becomes searchable by customers online. If you have similar images, save the caption for one and load it when you begin captioning others.

IPTC Metadata
Lengthy caption entries, including keywords and copyright notice, are accessible in Photoshop under File>File Info... Clicking Advanced allows descriptions to be saved and appended – useful if you have a number of images needing the same caption.

KEYWORDS

The value of a database lies almost entirely in retrieval – that is, how easy it makes it for a user to find a suitable image. As images accumulate in the database, it becomes increasingly difficult even for the person who took them to remember the details, and if you want other people to be able to search through your library of pictures, as for instance if you are selling them as stock photography, you will certainly have to anticipate how they might search. The software issues are highly technical, but common to all is the concept of keywords. These are words describing some aspect of an image; when someone enters a word in the search box of the database, the program will look for images that have the same word attached. The more varied yet apposite the set of keywords attached to each photograph, the better the chance of matching the searcher's request. The trick is in imagining what other people might look for, beyond the obvious description.

SUBJECTS AND THEMES

Potentially, travelling covers the full spectrum of photographic content, with the emphasis on the documentary and actual rather than the constructed. Running throughout is the idea of difference – the diversity of landscape, of climate, and above all of culture. Among the subjects that present themselves to the camera on a journey, especially when abroad, nothing approaches the complexity and variety of people themselves.

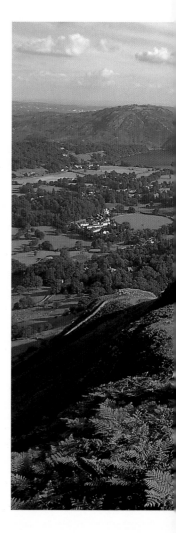

Whatever the theme or subject that we feel drawn to when travelling, we always see it from the point of view of another culture – our own. The sights and events that catch the attention tend toward the exotic, a loaded term that is highly relative. It very much depends on who is taking the photographs, and who is looking at them. If you live in Europe or North America, a Buddhist temple will look exotic, while thatched, stilted dwellings may look picturesque. Naturally enough, things are likely to be reversed if you grew up elsewhere. What you have in common with other photographers who travel is that, on a personal level at least, your subjects are out of the ordinary. Rather than trying to show insights into what you know best, such as life in your hometown, the essence of travel photography is to get across the enthusiasm of seeing new places, people, and things. What may be unremarkable or even a cliché to the jaded eye of someone who sees it every day can be made into an exciting image by a photographer who comes across it for the first time. It's easy to become overfamiliar – the Eiffel Tower to many Parisians, an open-air market to almost anyone from a warm climate – and to forget that to a fresh eye they may be remarkable.

Lake District

One of the key compositional elements of getting a good image is finding the best viewpoint. This part of England's Lake District, near the town of Grasmere, is known for its rolling green hills, and these needed a moderate elevation to show them off.

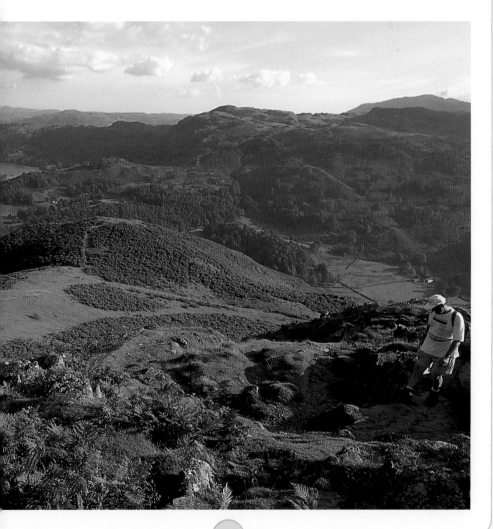

The journey

THERE IS A FUNDAMENTAL DIFFERENCE in approach between travelling to and travelling through. Time is a luxury that very few of us have as much of as we would like, and for the majority of people embarking on a trip, the idea is usually to get to the destination as quickly and painlessly as possible. This normally means by plane, and air travel is now one of the cheapest means. It is also typically organized, bland, and unexceptional. Add to this the strict security operating on aircraft and at airports and you have little incentive to include this part of the journey in the photography.

Which is a pity, because the process of travel is itself full of potential for experience, incident, and photography. There are, for example, the views en route. Carl Mydans, a veteran *Life* magazine photographer from the earliest days, thought that trains provided 'excellent opportunities' because they 'usually ride higher than the areas they pass through and the view from them is often commanding, surpassing what can be photographed from ground level'. Other means of transportation offer other, different windows on the land. Canals, for example, having been built for an older era in most countries, cut through countryside and urban areas against the grain of modern networks of road and rail. As Mydans put it, such transportation systems give 'chances to...photograph the backyards – the underside of a country's life that might be missed travelling by plane.'

More than this, the journey may provide you with a behind-the-scenes look at the transportation system you are using. Trains, boats, and coaches each have their own lore, and are generally not as restricted of access to photography as are aircraft (this varies from country to country). Even if you do arrive at your general destination by air, you are likely to be travelling on by different means within the country or region. Take the opportunity to discover what is special about the vehicles you use, and their drivers.

Orient Express
Run by the same company that owns the original, and still-running, Orient Express in Europe, this narrow-gauge train operates largely for tourists between Singapore and Bangkok. Life and activity on board makes a feature story for an American magazine, including Thai classical dance performance in the swaying dining car and the cramped but highly efficient galley operation at meal times.

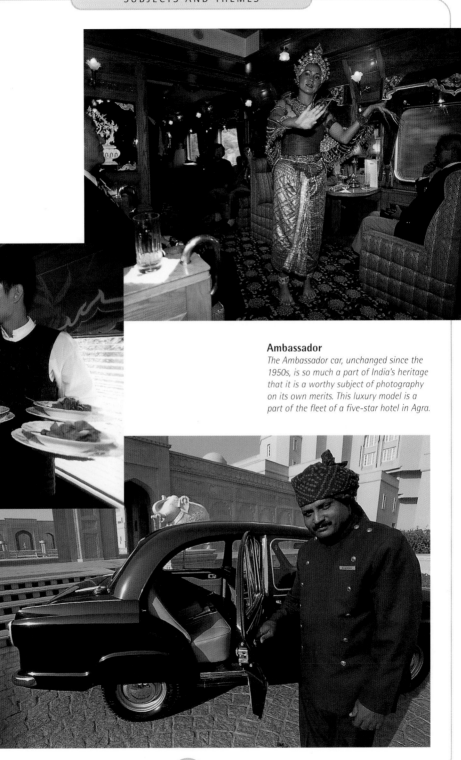

Ambassador

The Ambassador car, unchanged since the 1950s, is so much a part of India's heritage that it is a worthy subject of photography on its own merits. This luxury model is a part of the fleet of a five-star hotel in Agra.

Travel as a story

DEVELOPING THE THEME introduced on the previous pages – of the journey as a subject worthy of becoming a part of the overall photography – there are some circumstances in which travel, more than destination, can be made the subject. One such occasion is a cruise, and in particular the cruise shown here, in the eastern Mediterranean on a four-masted schooner, newly built but to a traditional design. Unlike normal cruise liners this vessel, the Star Flyer, carried only a hundred passengers and did so mainly under sail. Inevitably, despite the obvious attractions of the Greek island ports of call, such as Mykonos and Patmos, the workings of a sailing ship caught the attention of everyone on board. For some passengers, this was by far the main attraction. For me it was work, an assignment for a Japanese magazine. Technically interesting and supremely photogenic, the ship itself was the star of the week's cruise.

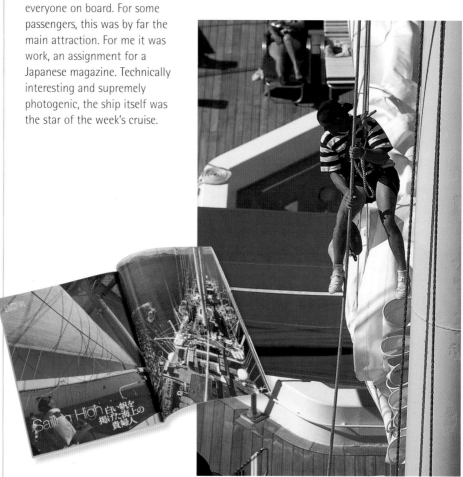

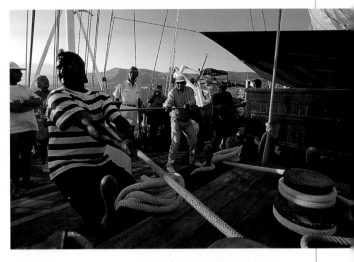

Street life

Towns and cities offer different kinds of photo opportunities – something of the landscape in overall views, and also a wonderful setting for people in all kinds of activity. Usually, the best way to deal with street life is to shoot unobserved, and there are a number of ways of doing this. The most direct is simply to shoot very quickly, quietly, and without fuss. This is easily enough said, and some great reportage photographers like Henri Cartier-Bresson have made this approach their hallmark, but it needs astute observation and fast reactions.

Try to anticipate what people will do next in any kind of situation – how they will react or look – because this will give you the edge in capturing the expression or movement. When you see the moment that you think is right, shoot without hesitating. Many people with a camera pause out of uncertainty before pressing the shutter, and lose the chance. You have nothing to lose by shooting.

For this kind of photography, particularly in the street or other public place, like a market, a standard or wide-angle

Horse and carriage
Tourists passing in front of the Palazzo dei Cavalieri in Pisa, northern Italy.

focal length is probably the most useful. A shorter focal length allows you to shoot from fairly close, which is useful if there are a lot of passersby who might otherwise get in the way. The difficulty is that people can also see you, which may make it impossible to get a second shot that looks natural. One technique that can help is to use a wide-angle lens but compose the view so that the person you are photographing is off-centre – in this way the camera appears not to be pointed directly at them.

You can also make good use of long focal lengths, although in a different way. A telephoto lens lets you stand at a distance, and there is every chance if the scene is busy that you will not be noticed – and so can go on shooting naturally. A medium telephoto, such as the equivalent of 180mm for 35mm, is particularly good for 'across-the-street' shots. Longer telephotos are more difficult to use because they are heavier, need faster shutter speeds to avoid camera shake, and draw attention. One technique is to sit quietly somewhere, such as a sidewalk café, and shoot from there. With all telephotos, there is a chance of passersby and vehicles crossing in front of the camera and spoiling the shot, so be prepared to shoot more frames than usual.

Chicago cow
One of more than 300 painted fibreglass lifesize cows placed around the city's downtown loop in 1999. The 'Cows on Parade' project was a huge publicity success for Chicago.

Old Nice
The Cours Saleya, combining fin-de-siecle architecture and market, typifies this old French Mediterranean port.

Overviews

CITYSCAPES AND URBAN LANDSCAPES in general often cry out for an overall view, an establishing shot that makes some sense of the jumble and detail of buildings and streets. Viewpoint is the first thing to consider, and tends to be more of a problem than in a natural landscape. You don't have unrestricted access, and the layout of buildings always narrows the choices of clear views. Cities surrounded by hills or built on hills, like San Francisco or Athens, have many good viewpoints, but they are the exception.

Some of the most effective shots are those taken at a distance and at some height with a telephoto lens. Try the following:

- The top of any prominent tall building. High-rise apartment buildings sometimes have open access, some public buildings may have purpose-built viewing galleries, but for offices and official buildings you would need advance permission.
- Any high ground, such as a hillside.
- The opposite side of a stretch of open ground or water, such as in a park, or on the other bank of a river.

Anticipate the lighting conditions that will give the effect you want. As with landscapes, a low sun in the early morning or late afternoon is usually more attractive than a high sun. Midday sunlight usually gives more contrast in a city than in an open landscape, as tall buildings cast large, strong shadows. Sunrise and sunset can be as effective as anywhere else. Cities also usually look good after dark, especially at dusk when there is still enough light to show the shapes of buildings.

Watchtower
A watchtower built on a hill overlooking the town and castle of Bouillon in the Belgian Ardennes is locally well-known, and quite easy to find from local tourist literature.

CITY LIGHTS

For a night-time shot, cities are more brightly lit after sunset, and more so in winter than summer, when offices are still full. Different types of light – street lighting, neon displays, and public building spotlights – are switched on at different times. Check the scene the evening before to guarantee the timing for the brightest array of lights.

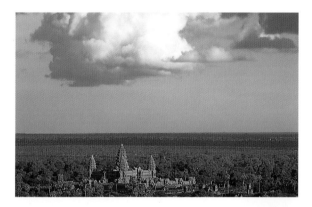

Angkor Wat
An isolated hill, Bakheng, less than a mile from the temple of Angkor Wat, gives a classic view – indeed the only overview possible without an aircraft.

Blenheim
No elevated view of this famous English stately home, but a clear shot from across a huge lawn, taken with a shift lens racked up to make more of the sky.

Kuala Lumpur
The skyline of Malaysia's capital, including the Petronas Towers (for a time the world's tallest building), becomes worthwhile as an image only through being framed here by the verandah of an old hotel.

Markets

ALL DESTINATIONS have their share of life, art, and nature: the full range of subjects for the camera, but a few stand out for their special relevance to the traveller. Markets are among these because of their variety, liveliness, and for offering an instant window into local culture. A common situation on arrival at a new destination is that of unfamiliarity. The guidebook sights apart, where do you find a concentration of people in a photographable situation? Markets are the reliable constant the world over. They are where people congregate to buy, sell, exchange, gossip, and they make an ideal entry point for photographing the community. If nothing else, an hour or two at the market is a kind of photographic exercise, a way of limbering up and brushing up your shooting skills if they're a bit rusty.

Mercato Centrale
Florence's best-known food market is the Mercato Centrale, housed in a cast-iron hall dating back to 1874.

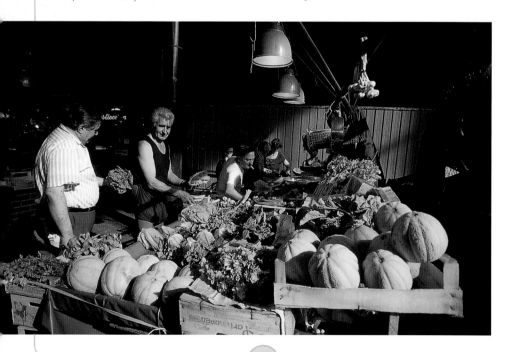

India (right)
Most Indian food markets are open-air. In a crowded street in Gwalior, a vendor weighs potatoes on a handheld scale.

Close-up (left)
The produce for sale is itself a potential subject for detail shots – here sachets of lavender in a Mediterranean French town, Moustiers-Ste-Marie.

Elevation (below)
The Grand Place in the heart of Brussels, arguably Europe's most beautiful city square, hosts a flower market during the day. I asked permission to climb to a balcony of the Hotel de Ville for a more graphic view looking down.

Worship

ANOTHER RELIABLE SITE where people congregate is, in most parts of the world, the local place of worship, whether a church, mosque, temple, or shrine. Like the market, there is usually a particular day and time for worship; unlike the market the activity is more serious and intense, and calls for more sensitivity on the part of the photographer. The possible restrictions were outlined on pages 114–117, Cultural restrictions, and I won't go over them again here, but always make sure that you know in advance what you can and cannot do. There is always someone to ask.

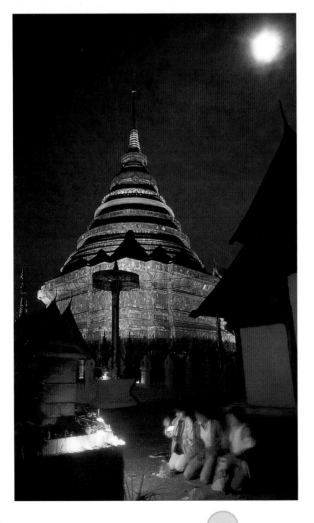

Northern Thailand: Buddhist

The year's principal festival at an important old temple in northern Thailand, Wat Prathat Lampang Luang, takes place on the day of the November full moon, so it made sense to shoot at the time and place where this would be visible.

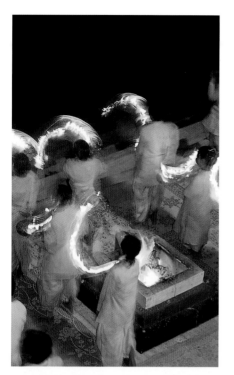

Rishikesh: Hindu
The evening Maha Aarti (great prayer ceremony) on the banks of the Ganges at Rishikesh, a notably sacred site where the river leaves the Himalayas.

Wailing Wall: Jewish
Praying at the Wailing Wall, also known as the Western Wall, in the Old City of Jerusalem, has been a Jewish custom for centuries.

Gometashvera: Jain
A major pilgrimage site for Jain worshippers in India is the 17m (56ft) statue of Gomateshvara at Sravanabelagola. The huge feet, over which milk is poured during a ceremony, convey the scale even more effectively than the entire statue.

Monuments and museums

ARCHAEOLOGICAL SITES call for many of the same camera techniques as regular buildings, but there are some other things to consider. Some of the more remote, or extensive, sites offer possibilities for very evocative photography. The temples of Angkor in Cambodia are perfect examples of this kind of monument. On a smaller scale, there are similarly atmospheric sites everywhere in the world; only the most accessible and famous, like Stonehenge, the Pyramids, and the Parthenon are under so much pressure from tourism that photography is restricted.

Nevertheless, access is usually the first consideration if you are planning to photograph an archaeological site. There are nearly always some kinds of restriction placed on entry (and an entry fee), to protect delicate monuments. Check these carefully before going, particularly opening and closing times, if any – you may want to shoot at sunrise or sunset, but not all monuments are open to the public at these times. In addition, check to find out if there are extra fees for photography – this varies from place to place, but in general you are more likely to be charged if you appear to be a professional photographer (see page 120, Legal restrictions). Tripods may be banned (see page 118, Tripod restrictions). Light-sensitive artifacts, such as polychrome murals, may be off-limits for photography.

Ancient monuments more than most other buildings benefit from not having people in view, but with a large monument this is rare. The best opportunities are nearly always as soon as the site opens. Otherwise it is usually a matter of waiting for moments when other visitors are out of sight. For atmospheric shots, treat the site as you would a landscape, and try to plan the photography for interesting light – at the ends of the day, or possibly with storm clouds. Also look for wide-angle views that take in close details such as a fragment of sculpture, as well as the distance. In addition to these basic scenic shots, consider the more documentary shots, such as a record of a bas-relief and other carvings. Here again, the lighting is important: raking light across the surface is usually the clearest for carvings in low relief.

There was a time when many museums allowed photography, with some reasonable restrictions, such as not using flash. Looking in a volume of the famous *Life Library*

Chichen Itza
The statue of Chacmool, an Aztec god, in its typical but unusual posture. Statues are now rarely found in situ because of the danger of theft, making situations like this valuable for archaeological photography.

of *Photography*, I came across the following: 'One of the travelling photographer's greatest opportunities is to take his own photographs of the masterpieces of art preserved in museums. Many tourists let this chance slide because they think art museums are off limits to photographers. How wrong they are!' That was 1972, and how things have changed! There is now a worldwide curator culture aimed at maximizing profits and restricting public use and enjoyment. Most museums now do not allow casual photography. The procedures for shooting involve written permission, increasingly difficult to obtain, payment (often high), and restriction of use. As museums normally own the copyright in the works they exhibit, there is no way around this. The answer, if it qualifies as such, is just to try, but be prepared to give up when stopped. Open-air museums tend to be rather more relaxed.

David
Sometimes, stepping back from a close view of an art object in display is worth it to show the setting and people. Michelangelo's statue David is lit by daylight at the Accademia in Florence, Italy.

Musée Guimet
A stone Khmer statue at the museum in Paris founded with this large collection from Cambodia.

Scenics and viewpoint

AT SOME POINT on every trip to a fresh area of landscape, the need sets in to find the defining shot – the single scenic image that captures the sense of place. Landscape photographers do this all the time, and don't usually limit themselves to one view that encapsulates everything. It depends on interpretation as well as opportunity, and may take a day or two of travelling around before you have an idea of what makes the scenery distinctive. Sandstone mesas and buttes punctuating the great arid distances of northern Arizona, the bocage landscape of northern France that is dense with hedgerows, the succession of alps and hillsides in parts of Switzerland – these and countless others are the themes of specific landscapes.

Catching glimpses and building up a composite view as you travel is one thing; translating this into one image is quite another. One of the odd things that happens while travelling through any landscape, whether by car, boat, or train, is that the eye and mind 'see' a view that is in fact made up of many fleeting impressions. It's more akin to watching a movie, and when it stops – when the vehicle stops – the clear view of the scene usually resolves itself into a mess. Foreground obstructions in particular suddenly appear. Here is what the American landscape photographer Ansel Adams had to say about this phenomenon when taking one of his most famous pictures in Yosemite: '...one cannot move more than a hundred feet or so to the left

Keralan palms
In the local language, the name for the south Indian state of Kerala means 'coconut palm', which abound. An overview from a distance would be less typical and less effective than the view from a small boat crossing one of the many small canals in the backwaters.

Balinese ricefields
Clear light and an intense blue sky made this a shot to be sought after – with young rice just being planted, the water in the paddies would reflect the colour of the sky. It took some time to find a clear overview from a little higher up the hill.

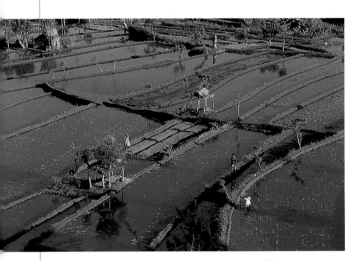

without reaching the edge of the almost perpendicular cliffs Moving the same distance to the right would interpose a screen of trees Moving forward would invite disaster on a very steep slope Moving the camera backward would bring the esplanade and the protective wall of rock into the field of view'. Adams was fortunate enough that there was a single good viewpoint. Often there is a frustrating lack of what the photographer has formed in his or her mind as the perfect view.

And here lies the problem – but also the solution. Expecting a certain kind of image without obstruction courts disappointment, even while it can also spur you on to making more effort. Lookovers, which we already examined on pages 138-139, are not the only camera positions, but they are the easiest to visualize. Viewpoint certainly makes or breaks a scenic shot, but it is often more rewarding to think through the

essence of the landscape. If a forest is too dense to allow an overall view, try to work with the denseness. Deserts, steppes, and plains are often unremittingly flat, but rather than look for a way out of this by finding an elevated viewpoint, why not stress the plain, simple horizontality with a dead-on, minimalist image?

Lake District
This part of England's Lake District, near the town of Grasmere, is known for its rolling green hills, and these needed a moderate elevation to show them off.

Emptiness
Rather than search for occasional strong features like an outcrop, I wanted here to convey the sense of emptiness in the northern Sudan desert. My only concession was a small shrub to emphasize a sense of loneliness.

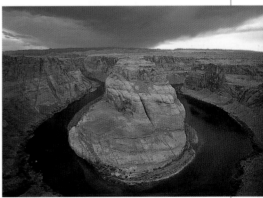

Horsehoe
A well-known view of the Colorado River near Page, Arizona, aptly named Horseshoe Bend. There is, in fact, little choice of viewpoint here, and it more or less dictates a very wide-angle lens.

Scenics and light

IF VIEWPOINT IS ONE KEY INGREDIENT in capturing a successful scenic photograph, the other is certainly light. The quality of light varies endlessly, with time of day, season, and weather. This is really all about timing, and having found the camera position that gives the essential view, you then need – or at least hope for – some special kind of daylight that will elevate the image from the documentary to the evocative. This, at any rate, is what most of us feel, even though the odds are, by definition, against us.

Above all, travelling ensures that you will never have enough time in any one place, for whatever kind of photograph. As photographers we are conditioned to want a certain specialness from a picture – something that sets it apart from others that have been taken before – and in shooting scenics this usually comes down to the lighting. As two pairs of photographs here amply demonstrate, in the right circumstance a shaft of sunlight can transform an image. There is just so much planning that you can usefully make,

particularly when travelling on a schedule: weather report, time of day, angle of the sun on key features. After that, it's a matter of how much time you are prepared to spend waiting for one shot, the odds of the light changing significantly in that time, and luck. The Spider Rock shot was definitely luck; the stormy sky held no good promise, and with no more than 15 minutes left before sunset, the view from this overlook would have been wasted if the sun had not broken through for less than two minutes. I was preparing to write off the afternoon's photography before this happened, but felt a duty to see it through, just in case.

Beyond all this is the matter of taste. The examples of lighting here are unashamedly picturesque, and you might prefer a more understated light. Choosing a certain viewpoint and composing the shot in a particular way means taking into account the distribution of light across the scene. Flat lighting, for example, is likely to suggest quite a different composition for one scenic location than would bright raking sunlight.

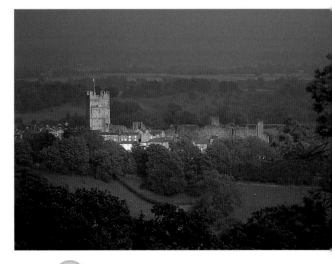

Passing clouds
The shot, of the Yorkshire market town of Richmond, was pre-determined as the job called for the first glimpse of it on a walk across England. The only variable was therefore the lighting, on a difficult day with strong winds and inconvenient clouds. The difference that a brief shaft of sun made is obvious.

Point Lobos

Shooting toward the sun with a long lens creates flare, but this can be used to advantage, as here with an early morning view of offshore rocks at Point Lobos, California, suffused with an orange glow.

Spider Rock

Even allowing for differences in taste, there is little doubt that this striking rock pillar in the Canyon de Chelly, Arizona, is best served by lighting that helps it to stand out from the surrounding sandstone cliffs. Even more than the images opposite, sunlight changed the view completely.

149

Beaches and resorts

TOURISM IS A MAJOR INTERNATIONAL INDUSTRY, and has a big impact on travel and travel destinations. Many of the most attractive locations, particularly if they are by the sea, are dedicated to holidays and leisure. They are an inescapable feature of modern travelling, although whether photographers find them a blemish or a picture opportunity depends on the motives for their own trip. If a holiday is your main purpose for travel, with photography as an extra, then you will probably be better disposed toward beaches, resorts, and the like, than if you are looking for the traditional ways of life in your chosen destination. Certainly, tourist resorts are usually far from the cultural life of their host countries, even while they may play a significant part in the economy.

In fact, these pockets of tourism have their own unique culture, and sometimes landscape, even if it may occasionally seem crass and vulgar. Treat them as another facet of travel and they can make worthwhile subjects. I should add that well-executed photography of beautiful resorts, performed without any sense of irony, is eminently commercial. There is a constant demand in the world of stock photography for images that celebrate the desirability of these destinations.

Beachscapes are a challenge for photography because their real appeal lies as much in beach culture and relaxation as in visual beauty. In fact, a flat beach of sand strewn with bodies usually needs some help to turn it into an attractive photograph.

Beach sports
Tourist beaches are prime sites for observing people displaying themselves in all kinds of ways.

Overview
A long shot of the same Greek beach as above. An establishing shot from a neighbouring headland.

One classic solution is to step right back, even as far as a headland, and use a long focal length to compress the various elements of the view: sand, palm trees, rocks, waves. At the same time, this approach tends to hide litter and other unsightly details. An alternative is the minimal: the deserted, away-from-it-all, dream beach. Here, the generally accepted ideal ingredients are a simple arrangement of deep blue sky, blue-green sea, white sand, and an elegantly shaped coconut palm. By definition these are hard to find, although the time of day may help. Early mornings have much to recommend them, with few if any tourists and the possibility that the tide has cleaned part of the beach of litter and footprints. The light at sunrise is also likely to be a plus.

Beaches and resorts do, on the whole, deserve to be seen in good weather and attractive light, and this is how most people like to think of them. That indeed is why they are seasonal locations, so if you are there during high season you will know what to expect. That said, photography is largely about surprises, and unusual lighting can work wonders.

Tropical remote
Late afternoon on an island in the Andaman Sea, capturing the essence of unspoiled nature.

Ayurvedic treatment
As usual, look for close-up details of interest – here a traditional oil-based ayurvedic treatment.

Himalayan spa
Yoga lessons at sunrise in a spa resort in the Himalayan foothills.

Country life

DESPITE THE HIGH VISIBILITY and impact of cities, most of the people on the planet still lead rural lives. For the traveller this may not be immediately obvious. Most journeys to other countries begin in a major city, often the capital, because it's nearest the arrival airport. Cities are, in any case, the hubs for travelling outward, and the easiest place to arrange itineraries, buy provisions, rent cars, and organize travel documents. Nevertheless, in terms of normal life and the average human landscape, the countryside dominates. On the surface, a pattern of rice fields glistening on a lush Southeast Asian hillside may seem exotically different from the flat wheat plains dotted with grain elevators in the Midwest, but the concerns of the people who live there are essentially the same. Life revolves around the seasons and the agricultural cycle. The busy times are planting and harvest; the communities are usually small; the weather determines the prosperity from one year to the next.

As you travel, keep this underlying continuity in mind. The specific activities you come across may be novel – repairing dry-stone walls on a Yorkshire moor, or bringing in baskets of harvested rice to a communal depot in upper Burma – and the dress and appearance of the people may lend an exotic character to the pictures, but the general purpose of life is pretty much the same. Knowing this, it helps in planning your shooting to find out what crops are grown, what animals raised, and so what activities are happening at this particular season. After the harvest is in, country communities the world over have time to spare – and this is not only when things get repaired and painted, but also when festivals, even marriages, are most likely.

Rural communities tend to be more conservative than those in cities, and customs more likely to be preserved.

Country life is also more distinctively regional than that of cities, where buildings, shops, and even the products for sale reflect globalization. The land and its potential can sometimes change sharply in several miles. With a sharp eye you can highlight these practical differences in your images.

Southern India *(right)*
A south Indian duck farmer shoos his charges across a small canal in the Keralan backwaters in the early morning.

English village *(below)*
A classic of its type, at least in terms of what people expect to see, is this view of a stone-built village in the Lake District of northern England. The viewpoint is down a steep approach road.

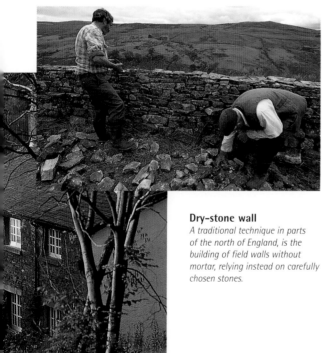

Dry-stone wall
A traditional technique in parts of the north of England, is the building of field walls without mortar, relying instead on carefully chosen stones.

Burmese rice market
Burmese women carrying sacks of rice from their own farms to the communal mill for weighing.

Mountain trekking

Planning a walking route is an effective way of covering the important locations, and this can be researched before arrival.

For a true sense of mountain landscapes, you need to walk into them. While roadside lookouts can offer good views, only trekking gives the opportunity of an in-depth coverage. As this means carrying everything you need, weight and bulk are issues; packing needs careful preparation. The breakdown of kit on pages 46–47 gives an idea of what is needed with a digital camera.

In this example, across the trans-Himalaya from northwestern Nepal into western Tibet and around Mount Kailash, the camping gear was carried by Sherpas and yaks. One unavoidable problem is that whatever equipment is in the backpack takes time to unload. This slows down the photography, but is a better option than carrying the camera loose and risking an accident. Backpacks often have a strap system that secures a camera to the chest.

Mountain areas vary in their picture possibilities, and it is important to cover all aspects. Dramatic landscapes figure strongly, and these depend mainly on two things – viewpoint and light. Mountain weather can be variable, so be prepared for a change in the light; early mornings and late afternoons are, as anywhere, often very good. This trek, however, offered much more in cultural material, as pilgrims from all over Tibet converge on the sacred mountain Kailash to circumambulate it.

Trekking: week one
The route for the first six days.

Altimeter
Includes a GPS receiver with barometric altimeter, electronic compass, and maps.

Chest strap
A cross strap when wearing a backpack to stop the camera from bouncing when walking.

Mountain light
Lighting effects are unpredictable, but it is worth getting up before dawn for whatever the light offers – in this case a view down the Karnali Valley toward Kanjirobe. This shot calls for a long telephoto; review the shot on the LCD monitor.

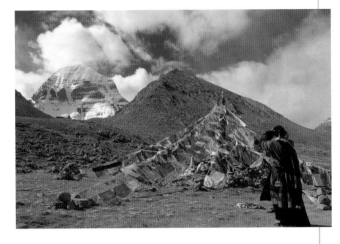

Pilgrims
Language is not a barrier under these circumstances, as everyone is in a cheerful mood. For this shot of a couple brewing yak-butter tea, the photographer sat down and made attempts at sign language.

Mount Kailash
The sacred circuit around the mountain is punctuated with viewpoints, as for much of the way the peak is obscured by nearer hills. Pilgrims have erected chortens bedecked with prayer flags at these points, and stop to pray. This is a moment obviously worth waiting for.

Prayer stone
A change of scale from the grand to the intimate adds to the variety of the shoot. An interesting feature of this landscape is the abundance of mani (prayer stones), engraved and left by pilgrims in piles.

Deserts

Deserts are defined by their lack of water – not precisely, but under 51cm (20in) a year, and in extreme cases such as the Sahara, less than 13cm (5in). In parts of northern Chile there may be no rain at all for between five and ten years in succession. Under these climatic conditions, the landscape can be highly photogenic, and certainly unusual, because there is so little vegetation. The scenery is bare and rugged, with all the geology exposed. Apart from the polar ice caps, the true deserts are the most hostile environments to life on the planet. All of this makes them wonderful sources of graphic imagery, made all the more dramatic by the clear sunlight that prevails. It also makes them potentially dangerous, and in terms of heat, dust, and sand they are unfriendly to camera equipment. See Protection from heat and dust on pages 60-61 for precautions.

Desert landscape varies in type more than most people expect, and it is certainly not all sanddunes. Desert pavement – known as reg in the Sahara – is a surface of rocks and gravel scoured by the wind, and is among the most common. Rocky uplands usually stand out abruptly from the generally level desert terrain, and are often sharp and angular from wind weathering and runoff erosion from the infrequent but powerful rains – in some areas, such as northern Arizona, these can take the form of dangerous flash floods that scour canyons (and cause deaths every so often). Dunes are less common, but once they have started to form they are self-perpetuating and very photogenic. What little vegetation there is tends to be in the form of scrub, grasses, and the latter in particular are very distinctive and make strong shapes.

The light in deserts is usually strong and bright, with well-defined sunrises and sunsets. Nights are often clear, giving some opportunities for shooting by moonlight. The relief and texture of sanddunes and rocks looks at its most dramatic in strong, low sunlight, and this is fairly reliable. Shadows take on special importance for photography. Even in the middle of the day there is an ethereal, hard kind of beauty. In canyons between high, close rock faces, the light can bounce around, tinged by the (usually) warm colours of the stone and the blue skylight. Circular polarizing filters in clear light have a very noticeable effect.

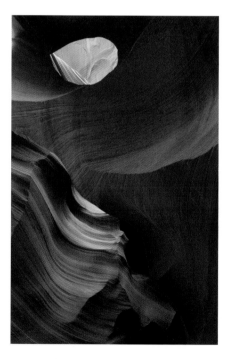

Slot canyon
A specific feature of northern Arizona is slot canyons. Eroded by flash floods (which make these canyons dangerous), and sculpted by wind and sand erosion, this canyon reaches more than 30m (100ft) deep.

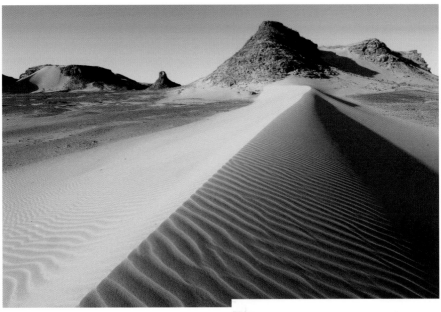

Dunes

A classic ridge dune tailing away from a rocky outcrop in northern Sudan. The angle of the light is important for revealing ripples and the granular texture.

Desertification

Deserts are rarely static, and over much of Africa the Sahara and its outliers encroach on inhabited areas, eventually smothering the land and forcing villagers to move on.

Camel route

The camel routes across this inhospitable African desert are dotted with the skeletons of camels that die of thirst and exhaustion.

Wildlife

A Western Blue-Tongued Lizard in Nambung National Park, Western Australia. With a name like this, there is an obligation to show the tongue!

Forests

THERE ARE SEVERAL KINDS OF FOREST and woodland, and the three most common of these are temperate deciduous, coniferous, and rainforest. Although many are under threat from logging and burning, they are still rich environments for nature photography (except for coniferous plantations).

Light levels tend to be low, particularly in rainforest, where the upper canopy of leaves effectively cuts off the ground from all light, and northern coniferous forests. Light levels may be too low for handheld photography and reasonable depth of field – as much as 12 f-stops less than the sunlight above. A tripod is always useful in these conditions. One benefit of deep forest gloom is that all the light is diffused and so contrast is low, and this helps to simplify the tangle of vegetation. At the same time, this diffusion can give a green cast to the image – this may even benefit the image, but remember that you can colour-correct with the white point balance, or later on the computer.

In less dense forests, and at the edges and along riverbanks, some sunlight penetrates. This tends to give a dappled effect, which might cause contrast problems. Look for subjects (flowers or animals) that are lit by patches of sunlight and expose for these. In fact, as a general rule, the woodland edges and glades have a greater variety of animal life. Large mammals are not common, but this lack is more than compensated for by the many different small habitats, with abundant plants, insects, and fungi. Close-up photography is particularly rewarding in woodland, but this in particular usually calls for a tripod.

Aspens in autumn
Aspens turning yellow on a hillside in Colorado. The angle of the sunlight, coinciding with that of the slope, makes the most of the intensity of colour.

Tropical rainforest
An aerial view of rapids and islands on the Upper Mazaruni River in Guyana. With dense tropical rainforest, an aerial perspective is often the only way to get a sense of the habitat in a single image

Temperate rainforest
(above and left)
Rainforest also exists, though rarely, in cooler climates, and one of the most extensive is the Hoh rainforest in Washington State on the northwestern coast. A clearing helps to open up the normally restricted view.

Tripod for low light
Forests generally have low light levels, and for static subjects such as plants, a tripod is essential. It helps if the design allows the angle of the legs to be adjusted.

In the detail

CLOSING IN ON THE DETAILS of a scene has a number of advantages in photography. One is that it offers a refreshing change of scale to the images. Another is that it encourages graphic experiment – such as in composition, cropping, and the juxtaposition of colours. And more than this, close-ups play a key role in interpreting content – isolating a detail to focus attention. While these are universal to all kinds of shooting, travel photography stands to benefit more strongly than most. A trip of a week or two will probably result in a large number of images, and a proportion of close-ups will add a valuable change of graphic pace. Photographs of people and landscapes tend

to conform to a relatively small range of compositions. There is nothing wrong with this, but close-up shooting allows a striking freedom of imagery, even to the point of offering a visual puzzle to the audience. Detail works in travel photography because it allows the observant eye to pick out the differences in material culture and in nature. For example, the way in which the sheaves of rice have been bundled, tied, and stacked by a Balinese roadside tells much about the islanders' way of life and their own attention to detail even in the most mundane of tasks. And the celebration of diversity is, after all, the underpinning of travel photography.

Kyoto doorway *(above)*
A Japanese tradition is the noren curtain, hung in front of restaurants, shops, and teahouses. The contemporary designs, featuring symbols or calligraphy, are usually of a very high standard.

Laotian temple *(left)*
Glass mosaic set into the wall of a Buddhist chapel at the temple of Wat Xien Thong, Laos, Luang Phrabang, has a naïve charm.

Balinese rice *(above)*
Sheaves of freshly cut rice neatly tied and stacked by the roadside in Bali, awaiting collection.

Ginseng shop *(left)*
Shop signs are always worth looking for, particularly when they offer something out of the ordinary – here ginseng in an old-fashioned Chinese shop in Malacca.

The ordinary

Lou Klein, the Art Director at Time-Life whom I quoted at the very beginning, began one briefing for a book I was about to do on a European city by saying 'I want to see what the milk bottles look like'. He was not being literal (although I did bring back a photograph of a bottle on a doorstep just in case). It was by way of encouraging me to shoot the ordinary, everyday things in another culture, to give an accumulated picture of daily life. By doing this it should be possible to convey something of the experience of being a part of another community – also its similarities to and differences from our own. Photographs of ordinary life and its details are potentially absorbing to anyone from another culture, because they can at the same time relate clearly to everyday reality anywhere yet also highlight a way of doing things that has evolved separately. This is all about people going about doing unexceptional things just as you would on an unremarkable day – but in an unfamiliar environment. Just as the exotic can be made familiar through photography, so the ordinary can be made into something that calls for attention.

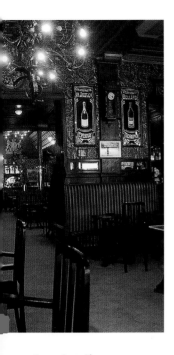

Brussels café
Cirio is one of Brussels' traditional café-restaurants; little changed in a century, with a regular clientele. Early weekday mornings are always quiet.

Street life
A group of friends outside a café in a small French Provençal town.

Balinese offerings
An island of Hindu tradition in a largely Muslim Indonesia, Bali continues to follow a largely rural way of life, despite the tourist industry. Offerings and ceremonies are the norm rather than the exception.

A game of boules
On the waterfront at Cassis, a small French port near Marseilles, locals pass an afternoon playing the traditional game of boules.

163

The unexpected

One of the paradoxes of travel is that it can always be relied on to deliver the unexpected. This sounds contradictory, but on the basis of experience it's true. Of course, the odds of coming across the undeniably strange corners of life are distinctly improved by travelling to, or at least wandering about in, the less obvious tourist destinations – and by doing this frequently. As far as most photographic opportunities on the road are concerned, time spent at a destination is subject to the law of diminishing creative returns. The excitement of a first sunset, then sunrise, at a Grand Canyon overlook is slightly diminished on the following day, and it doesn't take long before you exhaust the obvious. But the unpredictable, slightly weird moments that stop you in your tracks behave differently. They keep on coming the more that you travel, albeit at a much lesser frequency than the staple of scenic views, markets, and monuments. Naturally, only you are the arbiter of what counts as odd and quirky on your travels. Personally, I count the odder moments among the most satisfying from a trip.

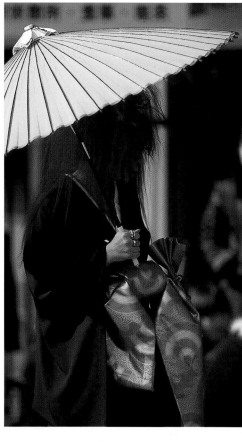

Japanese gothic
Since the 1960s, Harajuku in Tokyo has been a centre during weekends for the weirdest in youth fashion. It goes through changes year by year, with this odd mixture of Geisha and Goth current.

Ice hotel
A considered commercial enterprise certainly, but it is still remarkable that anyone would pay five-star prices to sleep on a block of ice in a hotel that melts every summer – the Ice Hotel in northern Sweden.

A helping hand

This enterprising coconut plantation owner in southern Thailand saved himself labour expenses by training local macaques to do the work of climbing the palms to collect the coconuts, and then help load them.

Customized paint job

For the Indian festival of Holi, the elephants of Jaipur, who live with their owners in the southeast quarter of the city, receive an elaborately designed coat of paint.

Reworking clichés

A STANDARD MANTRA of travel photography is 'avoid cliché!', as in 'don't waste your time taking another boring shot of the Eiffel Tower like everyone else/of Mount Fuji with a bullet train racing by in front'. Well, yes and no. Images become clichés in a two-step process – first, the view is good, second, many people take it. The word cliché comes from the French term for a photographic negative, from which identical prints can be churned out, so it's fitting that photography in particular suffers from this tendency to triteness.

However, the problem is often that there are natural viewpoints for many scenes that just happen to work very well; many if not most photographers would choose them without prior knowledge. There is one famous view of San Francisco from a grassy hill that takes in a row of Victorian gingerbread houses in the middle distance, with downtown beyond. It works, undeniably, and has been used endlessly.

Interestingly, there is just one small viewpoint from which you can see everything clearly and neatly arranged, and there is no missing the spot – the grass has been worn away by the feet of countless photographers.

There are many other examples, such as Angkor Wat from the other side of the northwest pond (the only spot that gives a reflection). The disappointment is simply that someone else got there first. As new destinations come onto the travel circuit, views that are fresh because rarely seen quickly become stale through repetition.

When faced with a popular subject, such as the Taj Mahal or Machu Picchu, the first question to ask is whether you are deliberately looking for a less-good viewpoint for the sake of being different. If you want eventually to sell the image as stock photography, that might not be sensible. It might be better to keep the viewpoint and work some other variation,

Taj Mahal
So heavily photographed is the Taj Mahal in Agra, India, that you might despair of finding a fresh view. Indeed, there really is no angle that has not been used before, but the head-on symmetrical shot down the length of the reflecting pools is certainly the cliché. More interesting graphically is the view from one side and farther back, through an arch. Not surprisingly, however, of these two images it is the cliché that sells best as stock photography.

such as unusual lighting, or having someone or something different in the foreground. Indeed, foregrounds can be the saviour of many views, because they make it possible to ring some changes by moving a little and perhaps by using a different focal length. The examples here are mini case histories – my on-the-spot solutions to very over-photographed locations. It is pointless to list the different compositional techniques and types of viewpoint, because such formulas are themselves clichéd. The only meaningful solution is to take time, explore, and be imaginative. And realize that any successful photographic treatment of a subject has the potential to become a cliché, simply by becoming popular.

Machu Picchu

This ancient Inca site in the Peruvian Andes is another location with one obvious viewpoint, endlessly reproduced. It does, admittedly strike any first-time visitor as impressive, and there is no point in not trying your own version. Nevertheless, I also wanted a slightly more original view, and found it on the path down from the first position. Fortunately, one publisher also wanted a different view for a book jacket, and this was the one chosen.

Civilizations
Ten Thousand Years of Ancient History

Jane McIntosh & Clint Twist

Internet resources

The Internet is now the first port of call for researching destinations. It owes its great popularity to one important application: the World Wide Web or WWW, or W3, or simply The Web. The World Wide Web is a network navigator and information system that makes all kinds of documents available (more than two billion at the last count). The most common information on the Internet is in the form of webpages.

HOW TO ACCESS ALL THIS INFORMATION? There are a number of ways, but the first step is to use a Web browser, the two most popular of which are Microsoft Internet Explorer and Netscape. Entering the URL (Uniform Resource Locator, the address for a webpage) in the bar at the top is the basic method of moving to a website. Here in this book I give some recommended URLs, and if you go to this book's website (www.trapus.web-linked.com), you can simply click on the many other links there.

But with two billion webpages, it is more likely that you will need to search for information. There are two kinds of Web search facility, although superficially they appear similar: search engines and directories.

Search engines
These use automated programs called spiders or robots to 'crawl' the Web and retrieve pages. They work by tracing hyperlinks across the Web, and this is made possible because webpages use HTML, or HyperText Markup Language. HTML documents are simple, consisting of a 'head' with a title and other basic descriptive data, and a body containing the document. However, search engines are by no means all-encompassing – research has shown that the eleven top search robots together only cover about 42% of the Web. First-generation search engines include:

Alta Vista www.altavista.com
(One of the three biggest Web page databases and one of the most frequently consulted search robots.)

Hotbot hotbot.lycos.com
(Also has a large database and extensive 'Advanced' search options.)

Excite www.excite.com
(A medium-sized robot which, if desired, integrates non-Web material.)

Because there is so much information on the Web, covering everything is impossible. So, second generation search engines have been developed to work in a smarter way. They use algorithms and other techniques to assess the importance of a site. The most popular is:

Google www.google.com

Directories
These are overviews of subject categories created by people rather than by crawlers. Sites are selected and placed in a hierarchy which can then be searched. Yahoo! is the biggest and most popular of these services, yet covers less than 5% of the Web. A variation is a metapage, which is compiled by an institution such as a university or a library and offers an instant choice of hyperlinks to a particular subject.

Directories include:

Yahoo! www.yahoo.com

Open Directory Project www.dmoz.org

Galaxy galaxy.einet.net

LookSmart www.looksmart.com

About.com home.about.com/index.htm

Lycos www-english.lycos.com

...and for travellers...

Virtual Tourist www.vtourist.com/webmap

Then there is the Invisible Web. Search engines (and these are, of course, used by the directory compilers), cannot access searchable databases, yet the number of these is increasing. One of the largest gateways to the Invisible Web is:

Invisibleweb.com www.invisibleweb.com>

Internet mapping

The interactive nature of the Internet makes it ideal for mapping services that allow you to specify the start and end points of your journey. The competition among these sites has also given rise to a number of interesting extra features, like aerial photography, something always worth a look at before going on location.

Multi Map www.multimap.com

Mapquest www.mapquest.com

Streetmap www.streetmap.com

SEARCH TIPS

- Spend a little time learning how search engines and directories work, and looking at the many options available. A number of sites offer this kind of information and tutorials, including: www.searchenginewatch.com/
 www.tilburguniversity.nl/services/library/instruction/www/onlinecourse/
- Use more than one search engine or subject directory.
- Be specific. Start by typing in a detailed rather than a general subject ('Tuolumne Meadows', if that's where you plan to visit, is faster than simply 'Yosemite', which will offer more webpages)
- Use a phrase search to be specific – that is, surround a phrase with ' '.
- Combine terms to close in on a subject, using +.

Internet resources

Government advice

The Internet has many valuable sources of information for travellers. For one thing, it makes getting hold of government travel advice very straightforward. The US State Department and Great Britain's Foreign and Commonwealth Office both publish and maintain background notes on any country you might be considering travelling to. You should also check the front page of their 'advice for travellers' sections, which will have any recently added advice.

United States Department of State travel advice travel.state.gov
background notes
www.state.gov/r/pa/ei/bgn/

United Kingdom Foreign and Commonwealth Office
www.fco.gov.uk

Health advice

Aside from concerns about personal safety, you should also be aware of health issues. Numerous organizations keep and maintain a list of health concerns, including the UN's World Health Organization's *International Travel and Health* guide, which is now published online and kept up to date. You may also be able to get advice from your healthcare provider.

UN World Health Organization
www.who.int/ith

US Center for Disease Control
www.cdc.gov/travel/index.htm

UK Department of Health www.dh.gov.uk

Travel Health Online www.tripprep.com

Equipment problems

It shouldn't happen, especially if you plan carefully and protect your equipment, but should you find yourself in need of a dealer abroad, you will be able to look up registered dealerships through your camera manufacturer's global website. If it's not possible to search a list directly, try calling the company's closest branch, since there is likely to be someone there who can help you out.

Canon www.canon.com

Fuji www.fujifilm.com

Nikon www.nikon.com

Olympus www.olympus-global.com

Pentax www.pentax.com

Sigma www.sigmaphoto.com

Sony www.sony.com

Communications technology

This is a collection of links to providers of high-tech communications technology, like satellite phones.

7E Communications
(satellite phones)
www.7E.com

Human Edge Tech
(expedition equipment)
www.humanedgetech.com

Inmarsat (satellite modems and phones)
www.inmarsat.org

Iridium (satellite phones)
www.iridium.com

Thuraya (GSM/satellite phones)
www.thuraya.com

Expedition resources, news, and journals

If you're planning an adventurous trip some way from the beaten track, it might be worth reading about those who've undertaken similar expeditions in the past. This collection of sites will help you do just that.

ExplorersWeb
www.explorersweb.com

Mountain Zone
www.mountainzone.com

One World Journeys
www.oneworldjourneys.com

Terraquest www.terra-quest.com

Web Expeditions www.webexpeditions.net

CONSUMER PHOTO-SHARING PORTALS

If you find yourself away from home for a long period of time, but keen to share the fruits of your photography with friends and family, you can use one of the many portals that are springing up. This wouldn't leave a great impression with a professional client, but then they will be better equipped to receive images, for example via FTP. To illustrate the simplicity of quickly sharing your images, we'll looks at the steps for Kodak's 'ofoto' service here:

- You'll need a computer with Internet access and a way to transfer your files to it.
- Copy your image files onto your computer in the usual manner.
- Before you can upload images, you need to register to the service. This is simply a matter of choosing a screen name and submitting your email address.
- Once you're logged in (or registered) simply click on the Add photos tab. You will be invited to add a name, then select the photos from your computer's hard disk.
- Click Next and your photos are copied to the Internet and displayed as an album.
- You can now copy the URL (address) of this album and email it to your friends, who can view it from any Internet browser.

Glossary

Archive
The process of organizing and saving digital images (or other files) for ready retrieval and research.

Bit depth
A pixel with 8 bits per colour gives a 24-bit per pixel image; the more bit depth, the more colours can be digitally represented.

Bit rate
The rate at which binary digits (bits) are transmitted. The bit rate is measured in bits per second (bps).

Byte
A group of 8 bits; a basic unit of digital information.

CCD
(Charge-Coupled Device). A light-sensitive imaging chip used in digital cameras. This chip sits in place of the film of a traditional camera.

CF
(Compact Flash) Card. The most common of several types of memory cards that are used in digital cameras. The CF 'Type 2' slot can also take a small hard disk (see Microdrive).

CMOS
(Complementary Metal Oxide Semiconductor). A light-sensitive imaging chip used in digital cameras. It is cheaper to manufacture than the CCD chip, but the results are virtually indistinguishable.

Compression
The series of algorithms applied to a digital image to reduce its file size without sacrificing quality, at least to a point. JPEG images are compressed, whereas TIFF is a 'pure' format.

DPI
The measurement of resolution by Dots Per Inch.

Fill flash
The use of a camera flash in daylight to fill in shadows.

Firmware
Computer instructions that are stored in a read-only memory unit rather than being implemented through software, typically camera-control software.

FTP
(File Transfer Protocol). An extremely simple and useful way of transferring large files from one computer to another.

Gamma
The midpoint between black and white in a tonal range.

GPS
(Global Positioning Service). A technology for identifying the exact location of a receiver using a network of Earth-orbiting satellites.

Histogram
The histogram is a graph showing the distribution of tones in an image.

ICC Color Profile
The International Color Consortium defines colour profiles to help get correct colour reproduction across devices.

INMARSAT
(International Maritime Satellite Network) An established and reliable network of five communications satellites in geostationary Earth orbit.

ISO
As with ASA on a film camera, a measure of light sensitivity. You can often adjust this just as you would switch films.

JPEG
The now-standard file format for digital images on the Web. JPEG, also known as JFIF, takes areas of 8 x 8 pixels and compresses the information to its lowest common value. Created by the Joint Photographic Experts Group.

Megapixel
The standard unit of measuring image size in digital cameras. One 'megapixel' is one million pixels.

Microdrive
The Microdrive is a small hard drive that fits either into Compact Flash media slots. They were the first 1-gigabyte memory card, and they now have capacities of up to 4 gigabytes. Microdrives utilize moving parts and are thus more susceptible to failure in extreme conditions.

Moiré
An interference pattern that occurs in print when dot screens are aligned at the wrong angles. The same effect can be produced by mismatched scanner-image resolutions.

Noise
The random pattern of small unwanted spots in a digital image that are caused by stray electrical signals.

Photoshop
A powerful software program from Adobe Systems used to manipulate images. Pictures can be dramatically changed using Photoshop: colours can be altered, images sharpened, parts of the picture removed or moved.

Photoshop Elements
A consumer version of Photoshop with fewer features, but is still very useful for manipulating images.

Photosite
The small area on the surface of a photodiode in a CCD or CMOS image sensor that captures a light level for a pixel in the image.

Pixel
Derived from the term 'Picture Element', the smallest unit of a digitized image. Each square dot that makes up a bitmapped image carries a specific tone and colour value.

PPI
Pixels Per Inch. A measure of the resolution of a bitmapped image. (See also DPI and Bit depth.)

Prosumer
A marketing term used to describe the intermediate market for camera equipment, between the consumer market and the professional market.

QTVR
(Quick Time Virtual Reality). An Apple format (and software program for stitching together a series of images) producing 360° panoramas or 3D object films that are navigable on the computer using arrow keys or a mouse.

RAM (Random Access Memory): The working memory of a computer, to which the CPU or central processing unit of the computer has direct access.

RAW
A file format created by most high-end (DSLR) cameras, containing all the pixel information with no compression. Each camera manufacturer has its own version of Raw. For Nikon, it is the Nikon Electron Format NEF.

Resolution
The amount of detail shown in an image, whether on screen or printed. Resolution is measured in dots per inch (dpi) in print or pixels per inch (ppi) on screen.

RGB
(Red, Green, Blue). The three primary colours of light, and the system used by computer monitors to display images.

ROM
(Read Only Memory): Any memory disk or media that can only be read, not written to. ROM retains its contents without power. Most CDs, once burned with data or images, become read-only (i.e. CD-Rom).

SD
(Secure Digital) Card: A postage-stamp-sized flash memory card that has a locking switch that can prevent accidental erasure of data once engaged.

Shutter Lag
The time elapsed between the moment when the shutter is depressed and when the image is captured, which can range from irritating to imperceptible in digital cameras.

ThreeG, 3G
A new 'third generation' wireless standard promising increased capacity and high-speed data applications up to 2 megabits.

Thumbnail
A miniature representation of a larger image file for onscreen viewing or printed contact sheets.

TIFF
(Tagged Image File Format). A cross-platform image file format for bitmapped images that has become a standard for high-resolution digital photographic images that are going to be printed. Some Raw formats are essentially TIFFs.

USB
(Universal Serial Bus). A standard port on most modern computers for the connection of external devices from keyboards to memory card readers.

White balance
A camera control used to balance exposure and colour settings to correct any colour cast that may not be visible to the human eye.

WiFi
From 'Wireless fidelity', used generically when referring to any type of 802.11 network, whether 802.11b, 802.11a, Airport, and so on.

Zip
A method for compressing files on a computer for storing and transmitting them at a reduced size.

Index

Acknowledgments

THE AUTHOR would like to thank all the following for their assistance in the creation of this title:

Apple Computer
Canon Inc.
Iridium
Lexar
Lowel
Lumedyne
Manfrotto
Mountain High Mapping
Nikon UK
Olympus
Sony

Special thanks to Arun Soni at
Film Plus
Unit 5
69 St. Marks Road
London
SW10 6JG